D1438929

C333066396

8115

A PRISONER'S HOME

8115
A PRISONER'S HOME

ALF KUMALO

and Zukiswa Wanner

PENGUIN BOOKS

PENGUIN BOOKS

Published by the Penguin Group

Penguin Books (South Africa) (Pty) Ltd, 24 Sturdee Avenue, Rosebank,
 Johannesburg 2196, South Africa

Penguin Group (USA) Inc, 375 Hudson Street, New York, New York 10014, USA

Penguin Group (Canada), 90 Eglinton Avenue East, Suite 700, Toronto,
 Ontario, Canada M4P 2Y3 (a division of Pearson Penguin Canada Inc)

Penguin Books Ltd, 80 Strand, London WC2R 0RL, England

Penguin Ireland, 25 St Stephen's Green, Dublin 2, Ireland
 (a division of Penguin Books Ltd)

Penguin Group (Australia), 250 Camberwell Road, Camberwell, Victoria 3124, Australia
 (a division of Pearson Australia Group Pty Ltd)

Penguin Books India Pvt Ltd, 11 Community Centre, Panchsheel Park,
 New Delhi – 110 017, India

Penguin Group (NZ), 67 Apollo Drive, Mairangi Bay, Auckland 1310,
 New Zealand (a division of Pearson New Zealand Ltd)

Penguin Books (South Africa) (Pty) Ltd, Registered Offices:
24 Sturdee Avenue, Rosebank, Johannesburg 2196, South Africa

www.penguinbooks.co.za

First published by Penguin Books (South Africa) (Pty) Ltd 2010

Copyright © Alf Kumalo 2010

ISBN 978-0-14302-659-4

Design and layout by Triple M Design, Johannesburg
Printed and bound by Imago

CONTENTS

ACKNOWLEDGEMENTS

I would like to thank the broader Kumalo and Kubheka families, with special mention of my younger brother Len and his son-in-law Shadrack Bokaba.

I thank all my colleagues from the various publications that I have worked for – the *Bantu World*, *Golden City Post*, *Drum Magazine*, *Sunday Times*, *Sunday Express*, *New Age*, *Rand Daily Mail* and *The Star* from my early years as a budding photographer – and the younger photographers I continue to meet and interact with today.

I would also like to acknowledge those who are not in the media but who have encouraged and inspired me to continue with this project. These are the people who helped me in my professional development and also moulded me as an individual: Can Themba, Nat Nakasa, Harvey Tyson, Dave Hazelhurst, Joel Mervis, Joe Thloloe, Aggrey Klaaste, Montsoia Moroke, Sol Makgabutlane, Herbert Mabuza, Maud Motanyane, Prof. Es'kia Mphahlele, Robyn Comley, Jon Qwelane, Steve Lawrence, Boxer Ngwenya, Paballo Thekiso, Kwame Pooe, Ruth Motau, George Mahashe, Zukiswa Wanner, Buyaphi Mdledle, Bongi Maswanganyi, Sipho Mbatha, Andile Komanisi, Dennis da Silva, João Silva, Greg Marinovich, Ken Oosterbroek, Kevin Carter, Bob Gosani, Theresa Skosana, Corrie De Haan, Bailey's African History Archive, Juda Ngwenya, Peter Magubane, Sam Nzima, Debbie Yazbek, Etienne Rothbart, John Hogg, David Sandison, Karen Sandison, TJ Lemon, Doc Bikitsha, Todd Matshikiza, Lucas Molete, Adriaan de Kock, Mujahid Safodien, Sumaya Samsodiene, Antoine De Ras, Lizeka Mda, Themba Hadebe, Siphiwe Sibeko, Louise Gubb, Vusi Nkosi, Fikile Mkhize, Dr Matlala, Khosini Nkosi, Thabo Leshilo, Phil Molefe, Prof. Phil Mthimkulu, Phil Nyamane, Mondli Makhanya, Ferial Hafajee, Moegsien Williams, Jovial Rantao, Bongiwe Mchunu, Stanley Motjuwadi, Desmond Sixishe, Joe Molefe, Derek May, Ron Anderson, Peter Sullivan, Patrick Laurence, Raymond Louw, Allister Sparks, Reuben Mabandla, Willie Moyo, Ruvan Boshoff, Prof. Herbert Vilakazi, Prof. Sam Shakong, Enoch Duma, Prof. Keorapetse Kgositsile, Harry Mashabela, Derrick Thema, The Nelson Mandela Foundation and Verne Harris in particular.

FOREWORD

Stories passed down as folklore and information shared through print can easily escape the human mind, while moments captured by the lens of a camera remain forever imprinted on one's heart and soul. We cannot afford to forget our history and nothing could convey it better than the images in this book.

8115: A Prisoner's Home is a pictorial record of the life and times of an international icon, compiled by one of South Africa's most accomplished photographers, Alf Kumalo. It is thanks to his camera that many people will now have an opportunity to appreciate and embrace the life of Nelson Rolihlahla Mandela through pictures that reveal both poignant and historic moments.

This book will enrich the souls of its readers, enabling them to reflect on the past as it is depicted in its pages and empowering them for the future. Alf's work not only brings back memories of the country's journey towards freedom but also ensures that we do not neglect the ideals and convictions of Nelson Mandela for political liberation and the broad-based economic development of our country.

The Industrial Development Corporation (IDC) is very proud to be associated with this work because it reflects South Africa's heritage and is a beacon of hope for our people. Alf Kumalo has dedicated his life to communicating stories through his camera and his images speak to the hearts and minds of the people.

Geoffrey Qhena, CEO
Industrial Development Corporation

I would like to dedicate this book to the Mandela family,
especially uBhuti Nelson noSisi uNomzamo

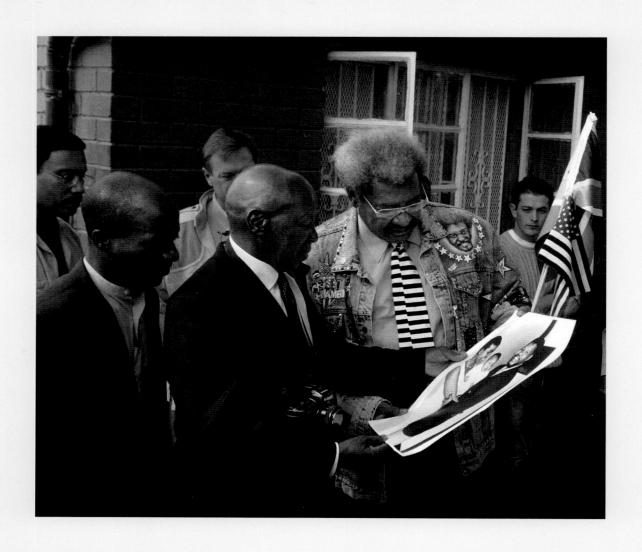

Alf Kumalo shows well-known boxing promoter Don King a
photograph of Nelson, Winnie and Zindzi on the occasion of King's
visit to 8115. This photograph was taken by Siphiwe Sibeko.

INTRODUCTION

Constructed in the early 1940s, the nondescript house located at 8115 Vilakazi Street, Soweto witnessed both violence and hatred throughout its existence. Its walls would be peppered with bullets, gutted by fire after an arson attack, and scaled during endless security police raids. Yet it would be the stage for some of the most important moments in recent South African political history – Nelson Mandela would return to this house after his release from prison; Winnie Mandela, for many years confined to 8115 while under house arrest, would continue her struggle against the unjust laws of apartheid and hold press conferences on the lawn and in the living room; and freedom fighters would use the house as a refuge and sanctuary.

For the Mandela family, though, it is more than just a house; it is a home that will forever be the place where many of their cherished memories were formed. Nelson Mandela would move here with his first wife Evelyn and their son Thembekile; Zindzi and Zenani, Nelson and Winnie Mandela's daughters, would read letters from their imprisoned father here; and family and friends would gather both to celebrate and to mourn.

The photographs in this volume, many of which have never been published in book form, depict some of these moments and give us the opportunity to peer within the walls of 8115 and share in the lives of its residents.

BEFORE ROBBEN ISLAND
1946–1962

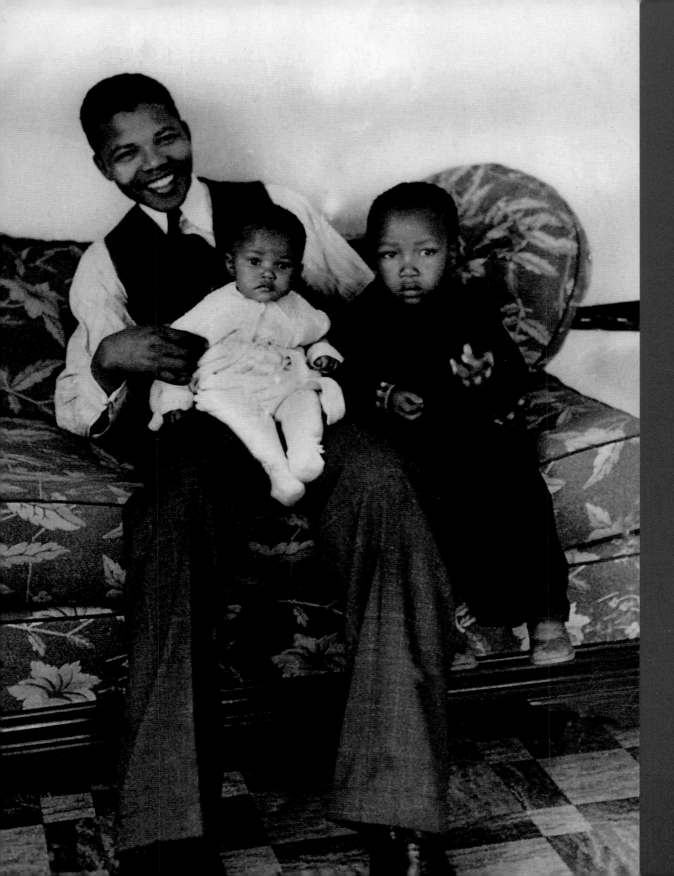

A 1951 photograph of Nelson Mandela with his son Makgatho (born in 1950) on his lap and his first-born son Thembekile (born in 1946) sitting beside him. Both sons were to die tragically. Thembi died in a car accident in July 1969 while Mandela was in prison on Robben Island. The authorities would not grant him permission to attend the funeral. Makgatho died of AIDS in 2005. With characteristic courage and openness, his father did not try to conceal the cause of his death from the public.

In 1945, when Jan Smuts was prime minister of South Africa, a nondescript, non-electrified, two-roomed house similar to many others in its part of Soweto was constructed at the corner of Vilakazi and Ngakane Streets in Orlando West and given the number 8115.

It could have been anyone's house, but it was not. This was the house where international statesman and South Africa's first democratically elected president, Nelson Mandela, would live.

In his autobiography *Long Walk to Freedom*, Mandela describes the house thus: 'The house itself was identical to hundreds of others … It had the same standard tin roof, the same cement floor, a narrow kitchen, and a bucket toilet at the back.' There was a cement sink, and curtains – instead of doors – separated the rooms. A red stoep, similar to that in many township houses of its kind, was the pride of the house but also torture for the female children as it had to be washed, polished and buffed to perfection to keep up with the neighbours.

Having stayed with his wife Evelyn's relatives upon first getting married, and then later moving to a small two-roomed municipal house across the bridge in Orlando East, Mandela was immensely proud about moving into the new house which, although still only two-roomed, was bigger by comparison. 'It was the very opposite of grand,' Mandela continues, 'but it was my first true home of my own.' The rent for the house was seventeen shillings and sixpence a month. Little did he know then of the history that would be made in this house, both in his presence and in his absence.

According to documents in the house, which is now a South African heritage site and a museum, Nelson Mandela moved into 8115 with his first wife Evelyn and their first son Thembekile in 1946. A year later a daughter, Makaziwe, was born to the couple but she only lived to be nine months.

In 1948, the National Party won the whites-only elections in South Africa and D F Malan became prime minister. It was in that year too that the African National Congress Youth League, then only a Johannesburg-based organisation, launched a campaign to establish itself nationally. Mandela, as secretary of the Youth League, was tasked with travelling to different parts of the country to establish the organisation more widely.

On the domestic front, 1950 saw the birth of a new child at 8115 – Evelyn and Nelson's second son, Makgatho. On the political front, South Africa saw the passing of three harsh laws which would make life very difficult for those opposed to the government. These were the Suppression of Communism Act, the Population Registration Act, and the Group Areas Act. In response, the African National Congress, in association with the South African Indian Congress and the Communist Party, called for 26 June 1950 to be a Day of National Protest. This was the beginning of what would become known as the Defiance Campaign. The modus operandi was to call for non-violent protests and work stay-aways to demonstrate disapproval of the government of the day.

With Mandela as a national organiser for the African National Congress (ANC), and therefore travelling countrywide, this period would mark the start of his being less of a resident and more of a visitor at 8115. If the walls of 8115 could talk, they would tell of their very first predawn raid by the security police immediately after the Defiance Campaign began. Mandela and many other leading organisers were woken up while the police searched their houses for documents that would implicate them in communist activities. Alas, Alf Kumalo was not there to see it. But there would be many other opportunities for him to do so at this very address.

On 30 July 1952, police arrested Mandela in terms of the Suppression of Communism Act at the law offices of H M Basner where he was working at the time. What became known as the Defiance Campaign Trial, with Mandela and nineteen other accused, took place in September that year and resulted in a sentence of nine months' imprisonment suspended for two years for all twenty accused. Despite this, the Defiance Campaign was to continue until December. In *Higher Than Hope*, her biography of Nelson Mandela to commemorate his seventieth birthday, Professor Fatima Meer recalls that Evelyn, with Mandela's mother and sister, settled down in a home run by women. Mandela spent brief periods at home, devoting a great deal of that time to playing with his sons. In the same year Mandela and Oliver Tambo set up their law office, thereby providing legal assistance to many Africans who would not otherwise have been able to gain access to lawyers.

The year 1953 saw 8115 inhabited mostly by Mandela's sister Leabie, his mother Nosekeni and the children. Evelyn had departed for Durban to do a course in midwifery. She returned in 1954 with her new child, a daughter named Makaziwe after the first Makaziwe who had died in infancy. Between Mandela's banning orders (the first one expired in 1953), the threats by the Law Society of the Transvaal to disbar him, and the constant absence of the paterfamilias, the pressure may have become too much for Evelyn. In 1956, she left 8115 with the children to go and stay with her brother in Orlando East. Evelyn told Meer that Mandela was a wonderful husband and a wonderful father. The children moved between their parents, from Orlando East to Orlando West. Maki was only two at the time and much too young to understand what was going on. Makgatho, at five, was young enough not to be bothered by it, but Thembi, who was eight, was deeply affected.

While the children continued to do things with their father, life was no longer the same and Mandela did not have much time to console them. A few weeks before Christmas, there was another predawn raid at 8115. Mandela was awoken by a banging at the door and when he opened it he was told to pack a few things because he was under arrest. The raid was one of a swoop that would net 156 people, all of whom were involved in campaigns of the Congress Movement. It would also mark the first of Mandela's two big trials and became known as the Treason Trial of 1956.

Finally, after a long separation, Mandela filed for divorce in 1957 and Evelyn did not contest it. Makgatho told Meer: 'My mother read in the newspaper that my father was divorcing her. It didn't worry me too much. As far as I could see, that had already happened a long time ago. My parents were living apart, we were going up and down between them, from Orlando East to Orlando West, then from the West to the East. In the dispute, I took my father's part.' Makgatho could not recall whether Thembi took the part of either parent.

Evelyn got custody of the children. She told Meer: 'The court gave me custody. Since Nelson had not paid lobola, he did not have rights over the children according to African law. This distressed him very much and he arranged with my brother to pay lobola . . . So Nelson did one of those rare things, paid lobola after the marriage had ended.'

It was around this time that Mandela started seriously courting a young social worker by the name of Winnie Madikizela. They had met through her friend and hostel mate, Adelaide Tsukudu (later Tambo). In early 1958, Winnie went to Bizana to get her parents' permission to marry Mandela. The wedding date was set for 14 June 1958 in Bizana. Mandela, who was under a banning order since the Treason Trial was

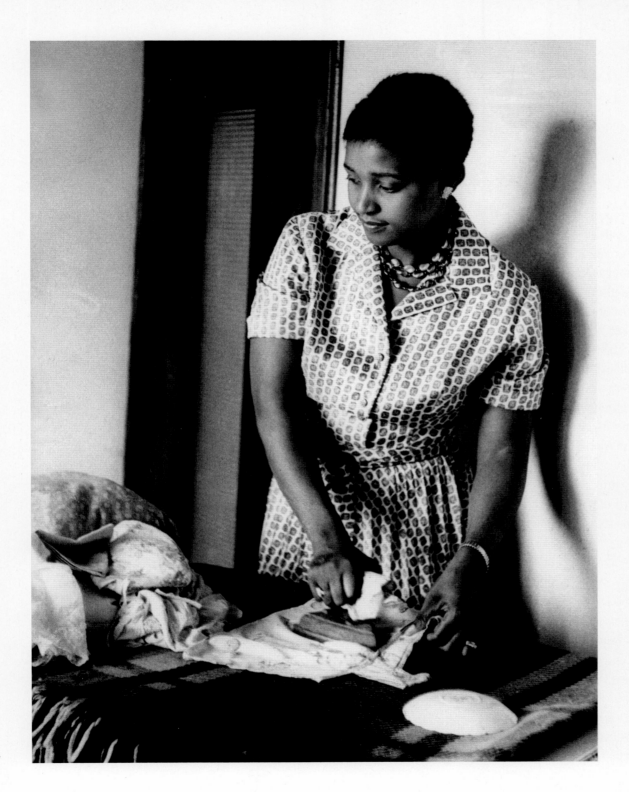

A pensive Winnie Mandela does the family's ironing. This picture was taken during Nelson Mandela's 'Black Pimpernel' days when he slipped out of the country without a passport to garner support for the ANC and to undergo military training. He travelled via Botswana (then Bechuanaland) and Tanzania (then Tanganyika) to Ethiopia where he addressed a conference of the Pan African Freedom Movement for East, Central and Southern Africa (PAFMECSA). He also travelled to Egypt, London and Morocco, where he received military training from the Algerian revolutionary army, and to Liberia, Sierra Leone, Guinea, Ghana and Senegal. At the end of his journey he returned to Ethiopia where he received military training at the headquarters of the Ethiopian Riot Battalion outside Addis Ababa. He returned home via Sudan, Tanzania and Botswana.

still in progress, had to apply for the relaxation of the order. He was given six days' leave of absence and drove with the bridal party to Pondoland. After the wedding, the bride and groom returned to Johannesburg where they waited until dusk before driving to 8115 to be welcomed by Mandela's mother, friends, and relatives.

Winnie entered a house which had much to displease her. In a recording about the house, she recalled her displeasure at the state of the cement sink. That said, there was also much that she recalled with pleasure. A bookshelf, a display cabinet, three cane chairs, a couch against the wall and, dominating it all, a picture of the bearded Lenin which was rather odd for the anti-communist Mandela. With Mandela still having to travel to attend the trial in Pretoria, there was little time for him to work at his law practice and Winnie, right from the beginning of her marriage, became the primary breadwinner.

After her marriage Winnie took to politics like a duck to water. She joined the Orlando West branch of the Women's League and in October 1958 she took part in a march to the Central Pass Office in Johannesburg to protest against the pass laws. She found herself, in the first trimester of her pregnancy, locked up with other women protesters at Marshall Square police station. They would later be moved to the notorious Johannesburg prison known as The Fort. The protests continued and the number of prisoners in The Fort swelled, leading to unhygienic conditions. The women were later tried, found guilty, and given the option of imprisonment or a fine. The ANC paid their fine. On returning home, Winnie discovered that her services at the hospital where she had been working were no longer required.

Winnie went into labour in the early hours of 5 February 1959. Mandela and Winnie's Aunt Phyllis rushed her to hospital and Mandela returned home from his trial hearing that day to find that he had a baby girl. His relative Chief Mdingi suggested naming her Zenani. Nosekeni returned to help with the baby. With little income coming in from the practice, Winnie and Mandela agreed that she needed to work. When Zenani was five months old, an opening came up for a social worker with the Johannesburg Child Welfare. She applied and got the job. Within months of Zenani's birth, Winnie discovered she was pregnant again. Unfortunately that pregnancy ended in a miscarriage.

Meanwhile, in the rural reserves of the Transvaal and the Cape, the ANC had been declared illegal by the Bantu Authorities. This resulted in great anger and people rose up against the tribal leadership. Their prime targets were Chief Botha Sigcau of Pondoland and Mandela's nephew, Kaiser Daliwonga Matanzima of the Thembu. In retaliation, the chiefs organised their mercenaries to attack anyone they saw as a threat.

This was followed closely by the outright banning of the ANC and the Pan Africanist Congress on 8 April 1960, in the wake of world attention focusing on South Africa after the widely documented horrors of the Sharpeville massacre the month before. Mandela and Winnie were now officially part of an illegal organisation. But the Pondo and Thembu people in the rural reserves did not acknowledge this and, later that year, a delegation visited 8115 to complain of the horrors being visited upon them by Matanzima and Botha. Mandela who, in their view, had authority both as adviser to the Thembu chieftainship and as a leader of the ANC, called in other ANC leaders. This situation caused some discomfort domestically as Winnie's father was aligned with Matanzima.

Winnie was pregnant again and in December 1960 gave birth to another baby girl during the Christmas adjournment of the Treason Trial. They named her Zindziswa.

By the end of the Treason Trial only thirty of the 156 original accused

remained, Mandela among them. On 29 March 1961, a verdict was reached more than five years after the trial began: 'On the evidence presented to this court …it is impossible for this court to come to the conclusion that the African National Congress had acquired or adopted a policy to overthrow the state by violence, that is in the sense that the masses had to be prepared or conditioned to commit direct acts of violence against the state.'

The jubilation at the 'not guilty' finding would not last long.

In April 1961 the ANC, together with other anti-government organisations, called a May Day general strike in protest at the National Party government's decision to declare South Africa a republic, thus severing all ties with the British Commonwealth, without consulting the African, Coloured and Indian populations. Mandela immediately went underground to organise the people.

It was during this time that the ANC decided that the time for non-violent protest was over and, with the approval of the ANC National Executive Committee, Umkhonto we Sizwe (MK) was born with Mandela as its first commander. The ANC had read the mood of the nation well. Other organisations had also seen the futility of non-violence against a brutal government.

On 18 October 1961, the country experienced its first act of sabotage by a group calling itself The National Liberation Committee. MK bomb explosions were later to follow on 16 December, marking the official launch of the armed wing and set up simultaneously in Port Elizabeth, Johannesburg and Durban. At the end of the Treason Trial on 30 March 1961, Mandela went underground. Thus was born the 'Black Pimpernel' and Mandela's appearances at 8115 Vilakazi Street would become even more rare. Still undercover, he left South Africa in January 1962 to garner support for the ANC and to receive military training. He left via Bechuanaland (now Botswana) and Tanganyika (now Tanzania) and travelled to Ethiopia for the 1962 conference of the Pan African Freedom Movement for Central, East and Southern Africa. He also made trips to a number of other African countries and to London before returning to Ethiopia for six months' military training, after which he made his way back home.

The police went on alert in June 1962 after seeing headlines that read: 'The Return of the Black Pimpernel'. The police and the residents of 8115 Vilakazi Street were to become even more familiar with each other after this. Fatima Meer mentions an incident when the police arrived on 20 June at ten in the evening but did not find Winnie home. Her sister asked if they had a warrant but was pushed aside and they went in and ransacked the house. Some youths in the neighbourhood decided to set the police motorbikes alight and the bikes exploded just as Winnie arrived home, which resulted in her being questioned about the incident.

In an article in the *Sunday Times* on 24 June Winnie told a reporter: 'The police have been making visits and searches at my house every night for almost three weeks. Whenever my children and I are about to sleep, security branch police arrive. They ask me where my husband is and sometimes search the house. Sometimes they joke and at other times they are aggressive which frightens the children. There are rumours that Nelson is back but I have not seen or heard from him.'

Mandela had, of course, found refuge at Liliesleaf Farm in Rivonia. His family would go to visit him there after making elaborate plans. On Sunday 5 August, the man the media called the Black Pimpernel was detained at a police roadblock outside the town of Howick, two hours after leaving Durban. It would be many years before he saw 8115 Vilakazi Street again, although other family members would remain there.

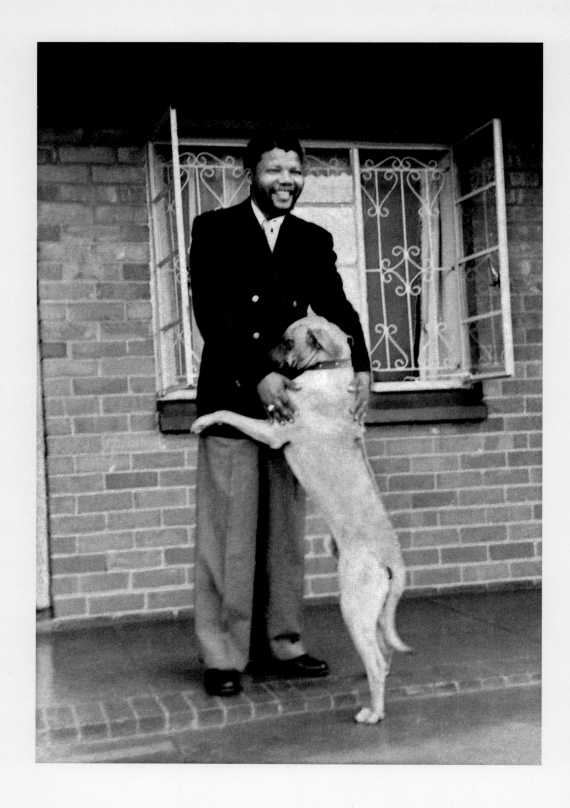

A relaxed Nelson Mandela plays with Gompo, the family dog, outside the house at 8115 Vilakazi Street. The photograph was taken in 1959.

A protective Gompo peeks out of the gate at 8115.

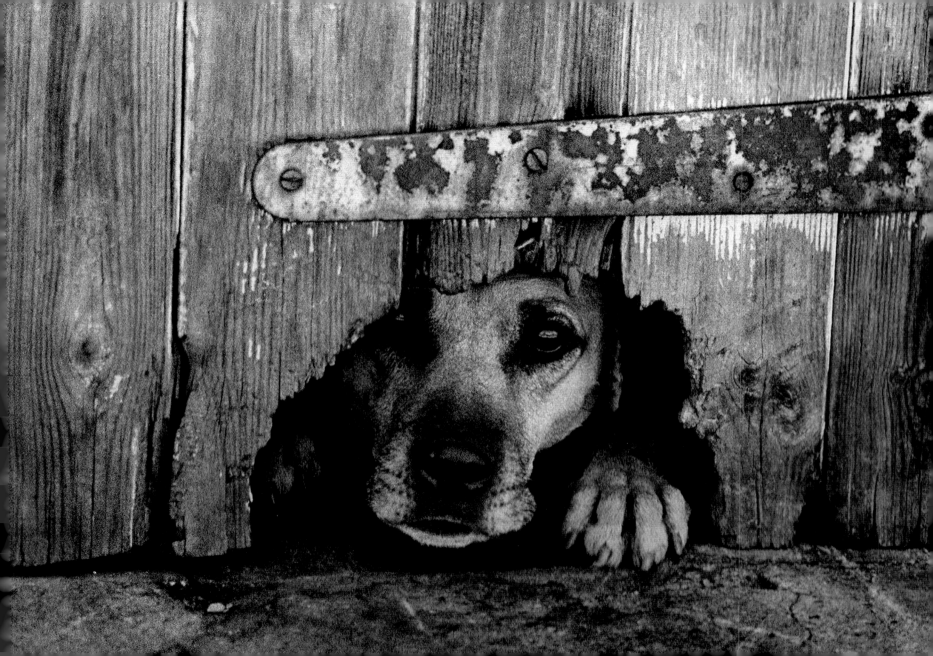

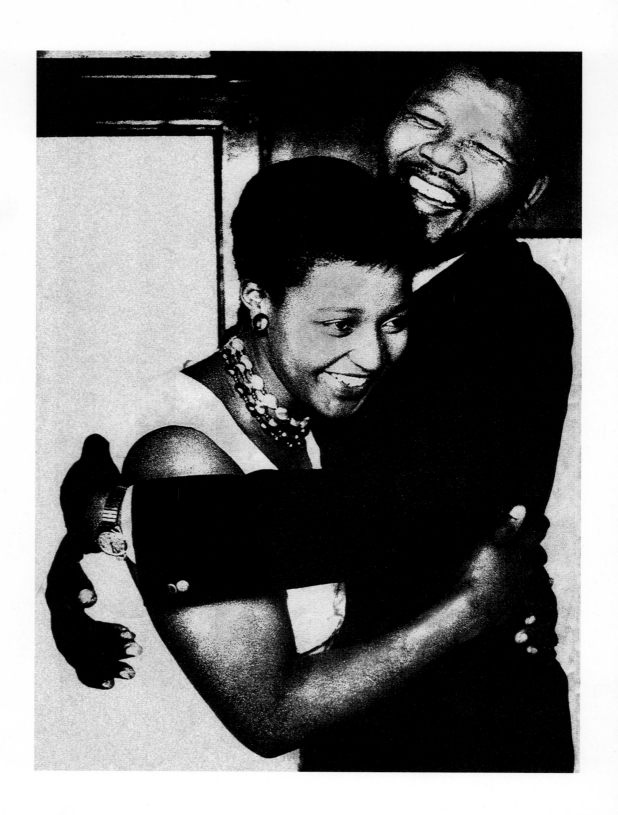

Young and happy. Winnie and Nelson
Mandela share a laugh.

Nelson and Winnie Mandela and
their two-month-old younger
daughter Zindzi who was born in
December 1960 during the Christmas
adjournment of the Treason Trial
in which Nelson Mandela and 155
others were charged with treason.
The trial ended in March 1961 with
the acquittal of the group of thirty
who had stood trial. The remaining
126 accused had had their charges
withdrawn at various stages in the
four and a half year trial.

PRISONERS IN OUR OWN HOME
1962–1990

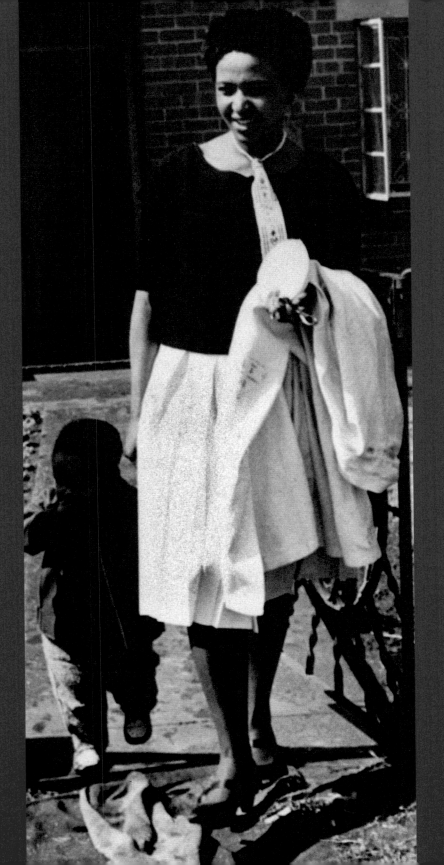

Winnie Mandela walking through the gate of 8115 with Zindzi beside her. This photograph was taken in 1962 after Nelson Mandela had been convicted of incitement and leaving the country without a passport and sentenced to five years' imprisonment on Robben Island. Winnie Mandela herself was serving the first of the banning orders imposed on her by the National Party government.

In 1962, the National Party government banned Winnie Mandela for the first time. In the same year, on 7 November, Nelson Mandela was convicted for incitement and for leaving South Africa without a passport. He was sentenced to five years, which he served initially in Pretoria but was transferred to Robben Island in May the following year.

On 11 July 1963 police raided Liliesleaf Farm, arresting high-profile members of the ANC and MK. They also found many incriminating documents, among them the M-Plan. Mandela was brought back to Johannesburg to stand trial with the Rivonia group. The trial, which became known as the Rivonia Trial, lasted until 12 June 1964. Winnie applied for a lifting of her ban so she could attend the trial and this was granted on condition that she did not 'dress or act' in a manner that would 'cause incidents'.

On 11 June 1964, Mandela, together with Walter Sisulu, Ahmed Kathrada, Govan Mbeki, Denis Goldberg, Raymond Mhlaba, Andrew Mlangeni and Elias Motsoaledi, was convicted on the charge of sabotage. The next day they were all sentenced to life in prison. Mandela returned to Robben Island with all his co-trialists, except Goldberg. Being white, Goldberg had to serve his sentence in Pretoria. Two months later, Winnie was given permission to visit her husband on Robben Island but could not travel with Albertina Sisulu, who had received permission to visit her husband Walter, because they were both banned people. Little did they know that the next visit would take place only two years later. On the second visit Winnie was forced to carry a *dompas*. After the visit, she was arrested at Cape Town airport and charged for failing to report her arrival to the police in Cape Town. She had already spent four days in prison when she was sentenced to twelve months in

prison, suspended for three years. During the next twenty-three years there would be many other conspiracies by the system to make these impersonal yet highly important prison visits between the two spouses uncertain until they actually happened.

Back in Johannesburg after serving her four days, Winnie started a job as a clerk at a correspondence college. But she was to lose that job because her banning order apparently did not permit her to attend an educational institution. With two daughters, a sick mother-in-law and an extended family that looked to her as the sole breadwinner, the road was getting tougher. In 1968 Nelson Mandela's mother, Nosekeni Fanny Mandela, visited her son together with his daughter Makaziwe, his son Makgatho, and his sister Mabel. She died that same year. Winnie and Prince Dalindyebo applied to the state for permission for Mandela to attend the funeral, but this was denied.

At dawn on 12 May 1969 there was a nationwide crackdown on the homes of political activists. One of the houses raided was 8115 Vilakazi Street. Winnie was woken up by the security police and, with her daughters clinging to her skirts, she was detained under the 1967 Terrorism Act. With twenty-one others, she was placed in solitary confinement and tortured. During Winnie's 491 days in detention, there was more bad news for the Mandela family. Nelson and Evelyn's firstborn, Thembi, died in a car accident in July 1969. Winnie could not attend the funeral as she was still incarcerated. She was charged under the Suppression of Communism Act but on 16 February 1970 all charges were withdrawn against all the accused. They were redetained as they prepared to leave court. In June of that year Winnie and nineteen other comrades were recharged, but all were acquitted on 14 September

1970. One can imagine that she must have been exhausted, but there was to be no rest on the part of the security police as far as harassing the residents of 8115 was concerned.

In 1971 a gunman was caught in the tiny yard of 8115. A year later, security police kicked down the door of 8115 and hurled bricks through the property. Winnie had had a wall built to separate the kitchen from the living room and so provide a bit of safety for the children. The security police used to shoot through the windows and she was worried that the children might be hit. In the documentary 'A Prisoner's House', Winnie, Zindzi and Zenani recount how they had to crouch down on the floor of the kitchen when the security police started shooting and breaking windows.

In 1971 Winnie and veteran photographer Peter Magubane, also a banned person, were arrested for communicating with each other. Perhaps the authorities feared that a picture might be worth a thousand words. They appealed against the charge. In 1973 she was again charged with violating her banning order and was sentenced to twelve months, suspended for three years.

In 1973 there was yet another raid by the police. As before, windows and doors were smashed, and this time anti-government leaflets meant to incriminate Winnie were dumped in the yard and someone saw fit to cut the telephone wires.

In 1974 she and Peter Magubane lost their appeal and both had to serve a six-month prison sentence. Winnie served her sentence at Kroonstad Prison in what was then the Orange Free State. She could have had no idea at the time that the province would host her again, and for a longer time.

The completion of Winnie's sentence in 1975 coincided with the expiry of her banning order. Fortunately for her, this time she was not rebanned. She went to Durban to attend a meeting of the Federation of Black Women and, having charmed everyone with her politics and her intellect, she was elected to the executive. Zindzi turned fifteen that year but Winnie altered her birth documents to show that she was sixteen. In *Long Walk to Freedom* Nelson Mandela explains her actions. 'Prison regulations stated that no child between the ages of two and sixteen might visit a prisoner ... the lawmakers presumed that a prison visit would negatively affect the sensitive psyches of children.' The lawmakers clearly had not thought how having a parent in prison could affect a child equally negatively.

Winnie recalls trying to explain to the children, who had been taunted by neighbourhood kids when they were younger, that the fact that their father was in prison was not because he was a criminal. While Zenani had vague memories of the father who went to prison and her visits to him at Liliesleaf Farm when she was younger (Mandela went to prison when she was four), Zindzi's visit was important to her because she did not know her father other than from stories, pictures, and letters. The plan went without a hitch and Zindzi was finally able to see her father in December that year.

On 16 June 1976, thousands of children made their way to Orlando Stadium from different schools in Soweto to protest against the use of Afrikaans as a language of instruction. Police followed their proceedings and opened fire on the students without warning. In the ensuing melee, twelve-year-old Hector Pieterson was shot and killed. There were to be many more deaths. The parents of Soweto responded to the

massacre of their children and the mass detentions of the youth leaders by forming the Black Parents' Association, in the hope of convincing the authorities of the importance of the youth's protest. Winnie was elected to this committee.

But the authorities were not in the mood for dialogue and the killings and mass detentions of children continued. 8115 Vilakazi Street assisted by hosting many a student escaping from the police presence at their homes, at high risk to the family members. Among them were the fiery Tsietsi Mashinini and a young Tokyo Sexwale who thanked the residents of 8115 for hosting him with a piece of art depicting a fist and captioned, 'Azania, Mayibuye'. Because of these visits, food was always prepared in abundance. On one occasion the security police raided the house after being alerted to the presence there of young student activists. Winnie remembers how a hungry young student escaped with *umgqhusho* (samp with beans) in his pockets.

The security police were not prepared to tolerate this blatant show of support from a woman they already considered dangerous. In August, Winnie was again detained under the Internal Security Act and imprisoned without charge for five months at The Fort in Johannesburg. Fortunately, Zindzi and Zenani were not there to witness this, as they were at school in Swaziland. But instead of breaking her, the prison term only led to Winnie's becoming more spirited and when she was released in December she continued working against an unjust system.

The year 1977 began on a happier note. Prince Thumbumuzi, son of King Sobhuza of Swaziland, came to 8115 to formally ask for Zenani's hand in marriage. Representing the Mandelas at the lobola

negotiations were Zenani's brother Makgatho; Mandela's nephew and now political nemesis, the Transkei homeland leader K D Matanzima; Winnie's sister and her husband, and, of course, Alf Kumalo was there to capture the beauty of the occasion. For the residents of the house, the happy occasion was probably a much-needed respite from the madness that descended on the house from time to time as a result of raids and disturbances by the police. But the happiness was short-lived.

On the evening of 16 May 1977, the police raided 8115 and began loading clothes and furniture on to trucks. Winnie was being removed from her sphere of influence. This time, she was not taken to prison but to the small town of Brandfort in the Orange Free State. Her banishment was so stringent that she was not allowed to receive visitors. The banishment was initially meant to be for four years, but Winnie was unaware then that, with the state likely to renew the order, she would stay in Brandfort for more than eight years. Zindzi went with her mother to their new residence – a three-roomed, tin-roofed shack. Makgatho and his first wife Rennie stayed behind at 8115. They would later have marital problems and leave the house. Winnie's sister and her husband, Nobantu and Earl Mniki, moved in to take care of the house. Meanwhile, both the Federation for Black Women and the Black Parents' Association were banned by the apartheid regime.

In 1979, the Indian government honoured Nelson Mandela with the Jawaharlal Nehru Award for International Understanding. With no chance of his leaving Robben Island to go to India to receive the award, the family applied to the government to grant Winnie a passport and allow her to go instead. The application was denied and in the end

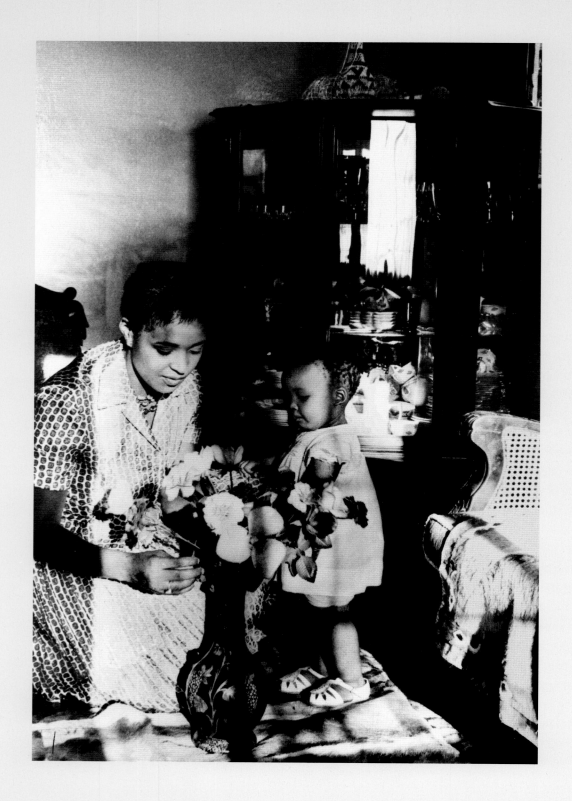

Winnie Mandela and a young Zindzi
arranging flowers in the living room
of 8115 in 1964.

Zenani, now with a diplomatic passport by virtue of her Swazi royal marriage, went to India with her husband to receive the award on her father's behalf.

At the end of the year, wearied by the constant persecution of her mother and the police raiding and questioning them even when her friends were visiting (Winnie was not allowed visitors but Zindzi was fully within her rights to receive visits), and perhaps not feeling too stimulated by the pace of life in the backwater town of Brandfort, Zindzi returned to 8115. She would be the constant resident there until much later in the next decade.

But, being her parents' daughter, she did not escape police raids at the house. In 1982, the security police yet again raided the house while she was there and confiscated books. The confiscation probably reflected police concerns about the mind of the youngest Mandela child. She had become a columnist for *True Love* magazine in 1977 and had an anthology of poetry published two years later at the age of nineteen; the anthology received a favourable review from no less a person than Alan Paton.

By this time, Mandela had been moved to Pollsmoor Prison in Cape Town. If nothing else, the move made it easier for his family to visit. He was also better able to strategise with his comrades as he was sharing space with Walter Sisulu, Raymond Mhlaba and Andrew Mlangeni. Not long afterwards, they were joined by Ahmed Kathrada.

P W Botha's South Africa continued to burn and to trouble the conscience of the world. 1980 saw the worldwide establishment of 'Release Mandela' campaigns appealing for the freedom of the famous prisoner. So ingrained did the campaigns become in the psyche of the world that an anecdote is often told of how a young child at a benefit concert was asked by a radio station announcer what Mandela's first name was and the kid responded, 'Free'. With pressure mounting from the international community, P W Botha offered Mandela his freedom in a parliamentary debate on 31 January 1985, on condition that he and his comrades rejected violence as a political instrument. After making that announcement Botha added, 'It is therefore not the South African government which now stands in the way of Mr Mandela's freedom. It is he himself.'

For Mandela to capitulate would have been like selling out to the outside world with no guarantees of freedom or democratic rule. He rejected the condition for his release in a letter to foreign minister Pik Botha. He also wrote a public response, giving the letter to a visiting Winnie and his lawyer, Ismail Ayob.

With Winnie still in Brandfort, the letter was read by Zindzi at a United Democratic Front (UDF) rally at Jabulani Stadium on 10 February 1985. The letter, which became known as the 'My Father Says' speech, ended with the words, 'Only free men can negotiate. Prisoners cannot enter into contracts …I cannot and will not give any undertaking at a time when I and you, the people, are not free. Your freedom and mine cannot be separated. I will return.' It would be exactly five years and one day before he fulfilled his promise to return.

In August 1985, Winnie's house in Brandfort burnt down while she was in Johannesburg for a medical check-up. She returned to Johannesburg, but was banned from living in Soweto. Winnie defied this. Soweto was, after all, her home. Showing their penchant for pettiness, the police raided her house on 21 December. Zenani, who had

tried to shield her children from the ugly side of politics, was on holiday with the children at the house when the raid happened. As the police arrested Winnie, the children's aunt remembers them standing aside in the street where they had been playing, staring in fear. Such was the impact of the arrest that a few years later when Winnie went to visit them while they were in school in the United States, they ran away from what they must have thought of as a jailbird *gogo*.

The police dumped Winnie at the Holiday Inn near the airport. When Zindzi found her she had walked to the railway station and was about to take a train to Phefeni Station. She eventually moved to the Indaba Hotel where she remained for about four months until, defiant once more, she returned to 8115. Although Winnie's banning order had been relaxed in that she did not have to return to Brandfort nor report daily to the police, she remained banned from the Johannesburg and Roodepoort magisterial districts. Early in January 1986 she once again returned to Soweto and was arrested and charged with breaking her banning order. This resulted in an international outcry and the case was eventually shelved. The police, perhaps aware that the attention of the world was on this particular house and their persecution of the wife of the world's most famous political prisoner, made no further attempt to remove her from 8115.

In 1986, Coretta Scott King, wife of the slain civil rights activist, came to visit Winnie to show some sisterly solidarity. And in 1988 the world commemorated Mandela's seventieth birthday. Then world heavy-weight boxing champion, Mike Tyson sent a delegation with a signed pair of his boxing gloves as a gift for the world champion of human rights. Mandela's grandson, who was nicknamed Gadaffi, proudly held his grandfather's gift and showed it off to the photographer.

On a more sombre note, following the killing of fourteen-year-old Stompie Seipei, for which a member of the Mandela Football Club was later convicted, students from Daliwonga High School set fire to 8115 in anger. Nelson Mandela asked that no criminal action be taken against the youths and the community rallied to help rebuild the house.

Two years later Mandela would be free and he would stay at the house for a while as well as conduct most of his interviews there. But the burning of the house had marked the end of the long-term occupancy of 8115 for the extended family.

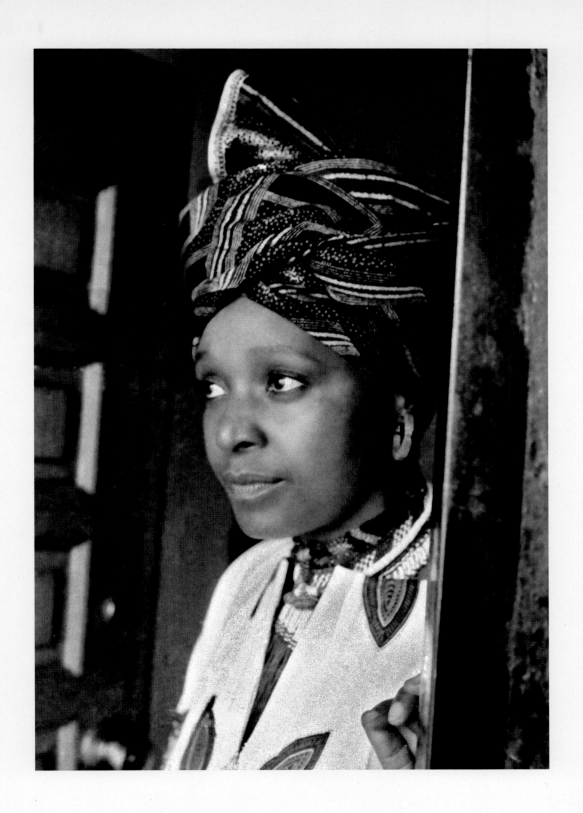

Winnie Mandela in traditional dress.

Winnie Mandela milking a cow while on a brief excursion away from 8115, in defiance of her banning order. Her cap is worn back to front to prevent the peak from getting in the way during the milking process, and her jacket is inside out to prevent it from becoming soiled.

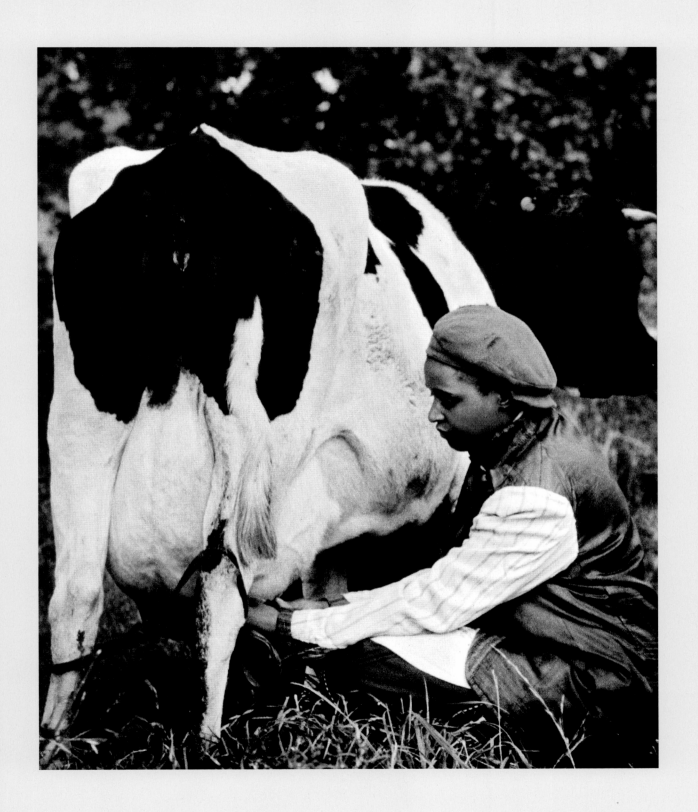

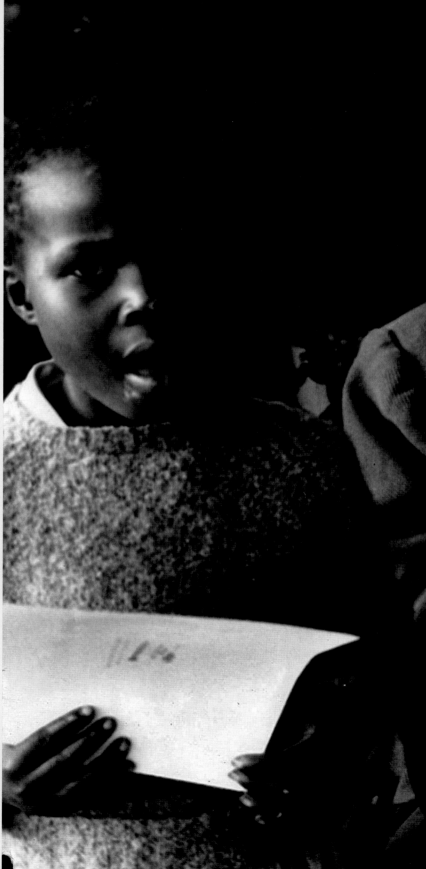

A mother remembers: Nosekeni Fanny Mandela holds up her son's photograph. Zenani is standing on the far right. This photograph was taken in 1964 after Nelson Mandela and his fellow Rivonia trialists were sentenced to life imprisonment.

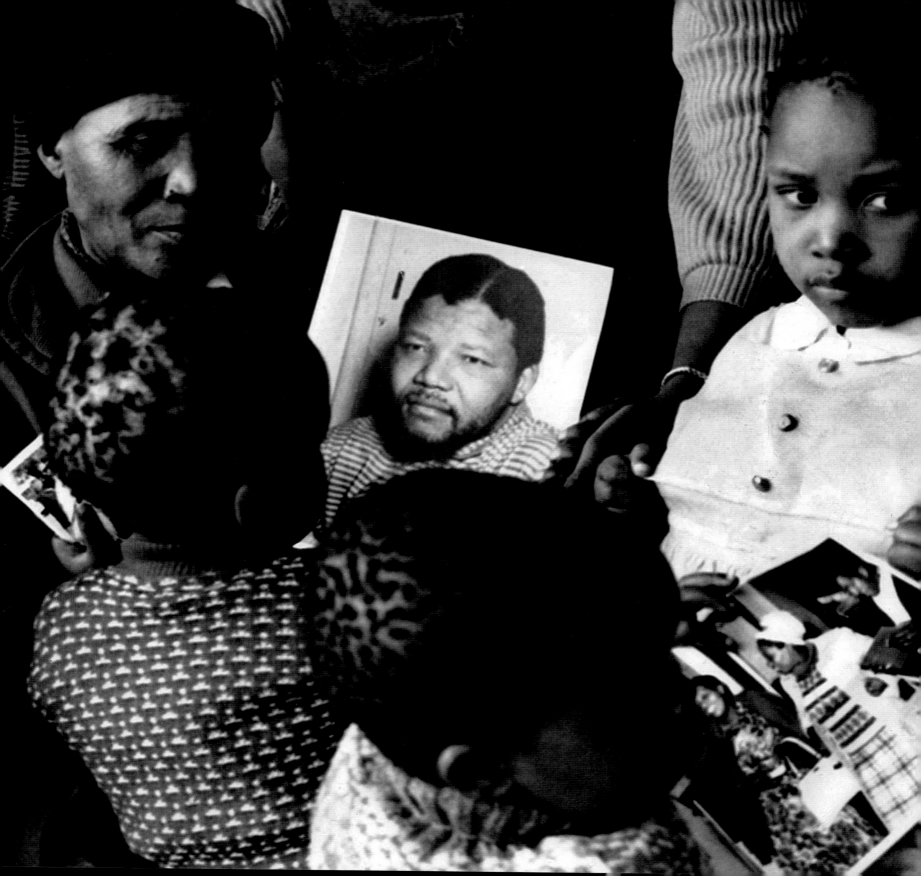

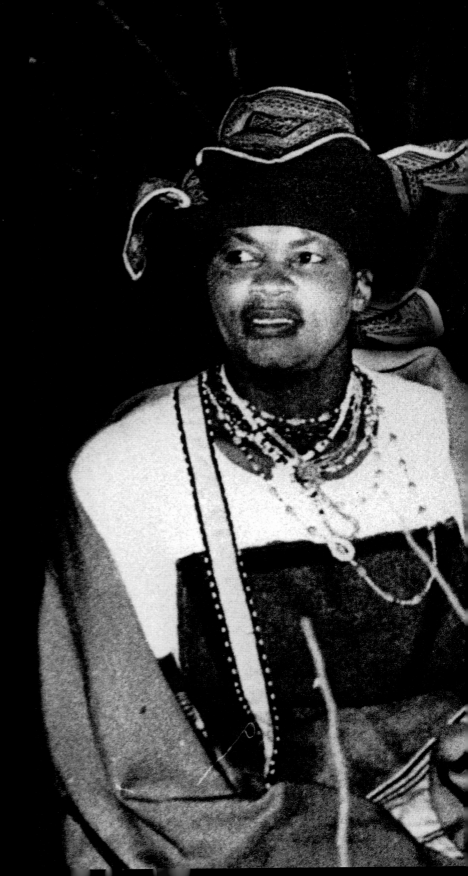

Winnie Mandela and Albertina Sisulu in traditional dress. Albertina's husband Walter was also a Rivonia trialist and sentenced, like Nelson Mandela, to life imprisonment. A vociferous anti-apartheid campaigner who was banned or restricted on and off for more than seventeen years, Albertina never gave up the struggle and addressed political rallies and meetings at every opportunity.

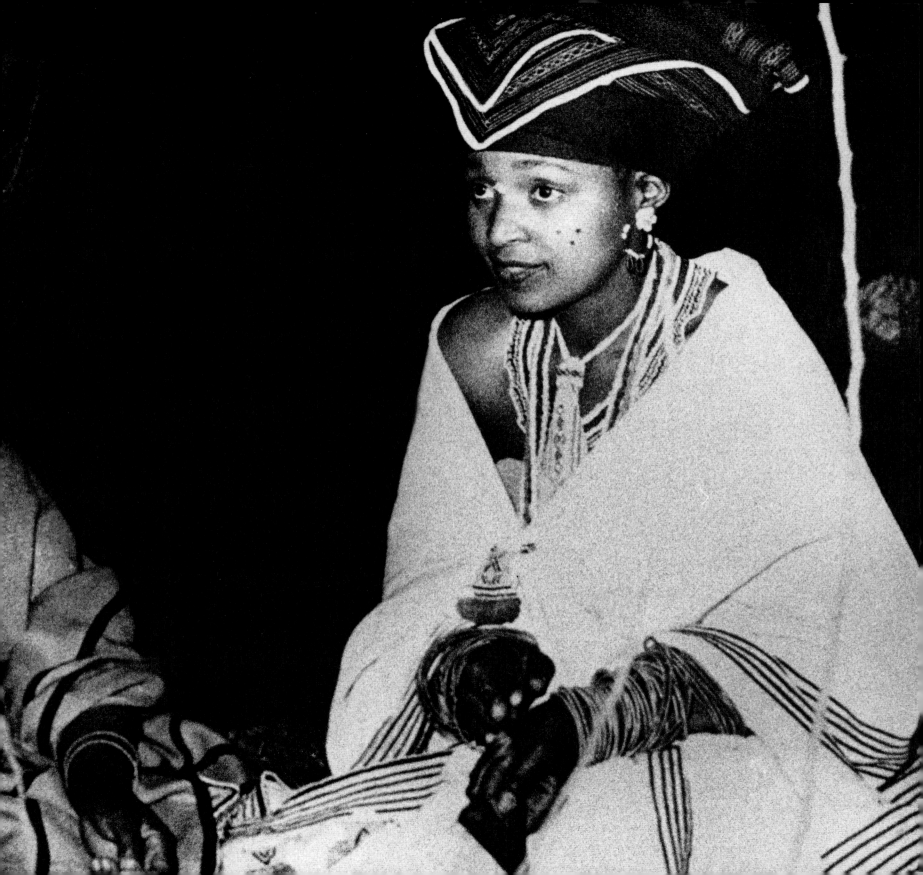

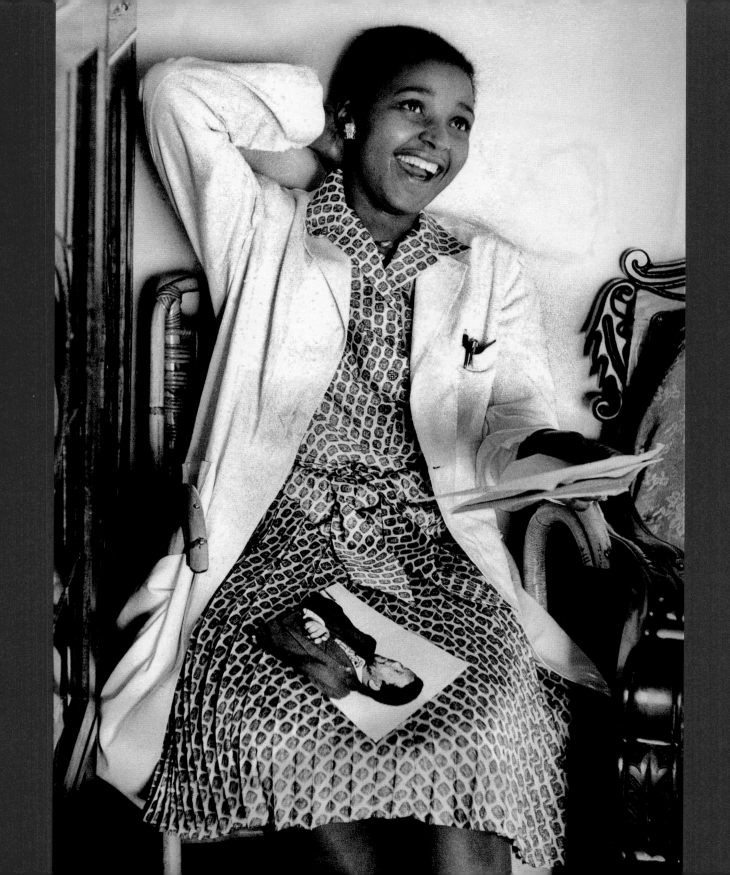

Winnie Mandela's face is radiant
as she reads the first letter
from her husband on Robben
Island in 1964. On her lap is a
photograph of Nelson Mandela.

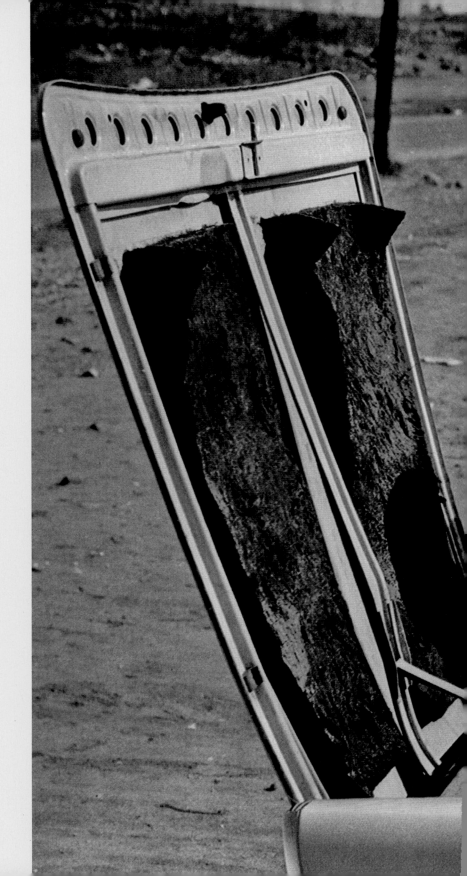

Winnie Mandela and Martha Mathlaku, a
family friend and businesswoman, tinker with
the car engine outside 8115.

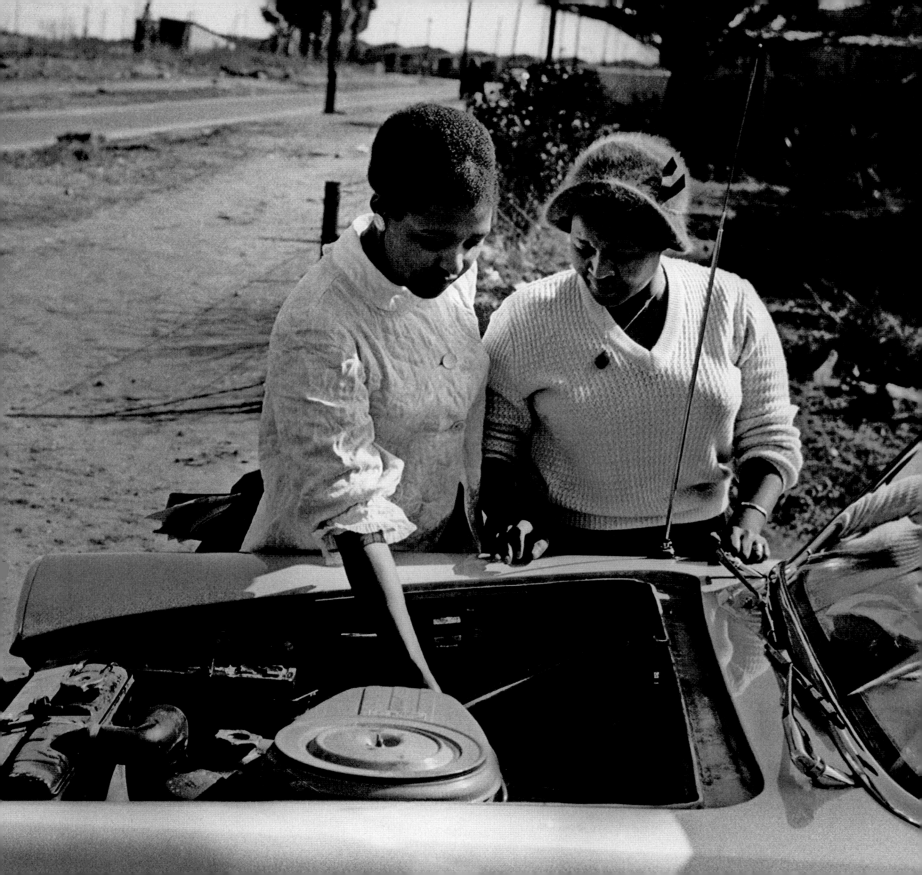

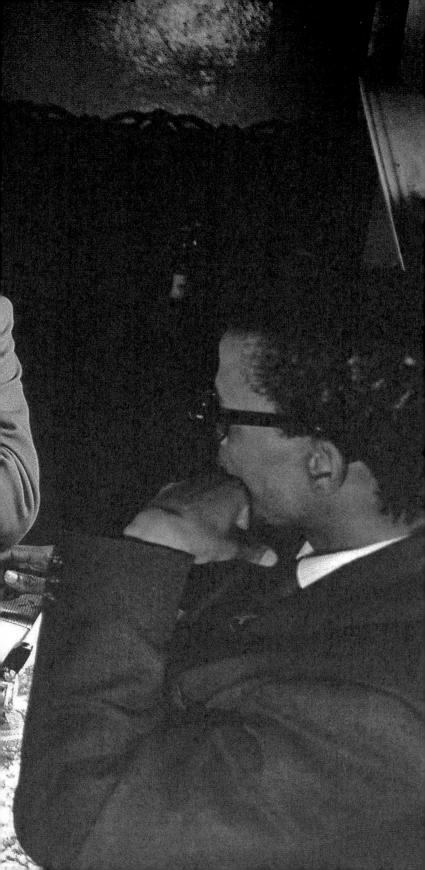

Winnie Mandela in traditional attire during a
specially arranged photo shoot at 8115.

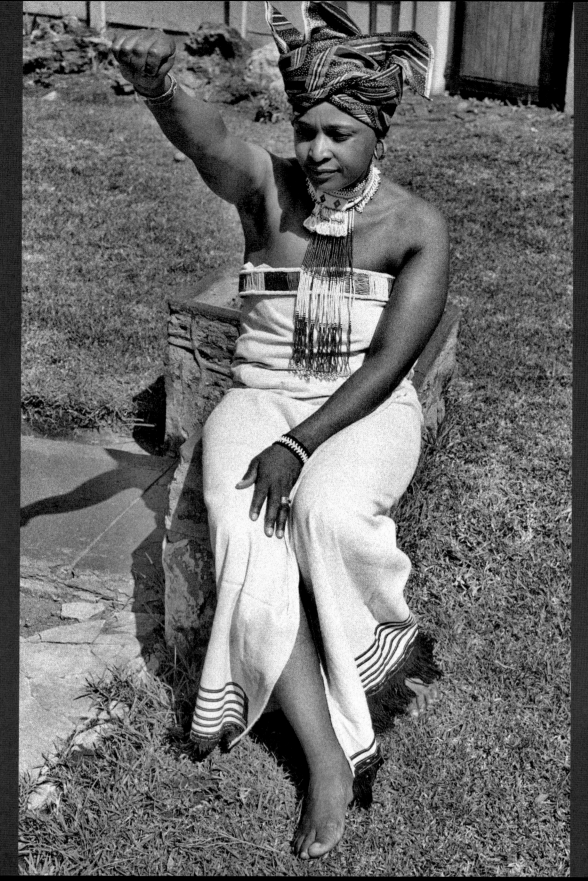

Winnie Mandela, in tribal
dress, gives the traditional
ANC clenched fist salute.

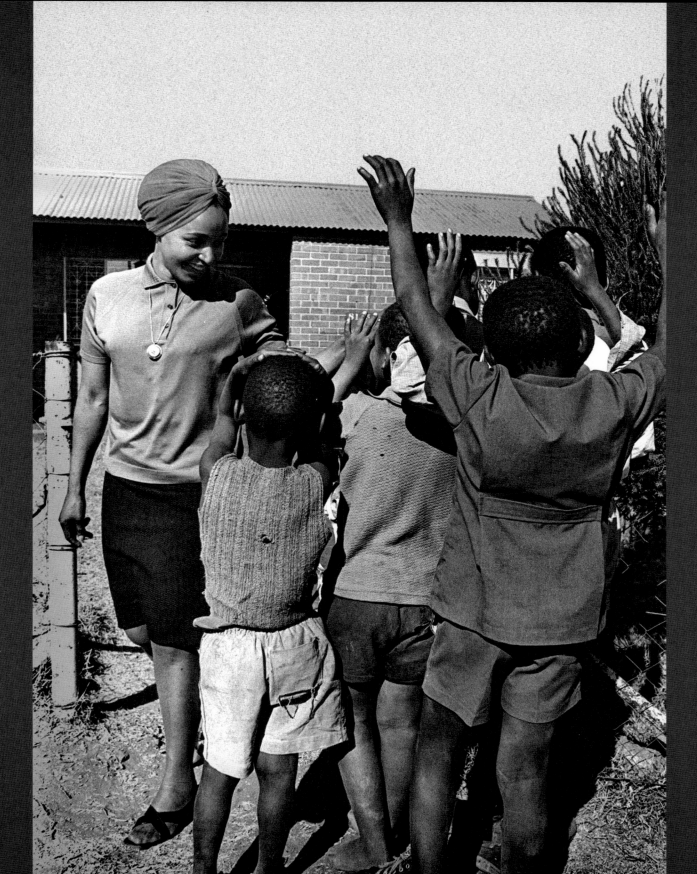

Winnie Mandela chats to neighbourhood children outside the gate of 8115.

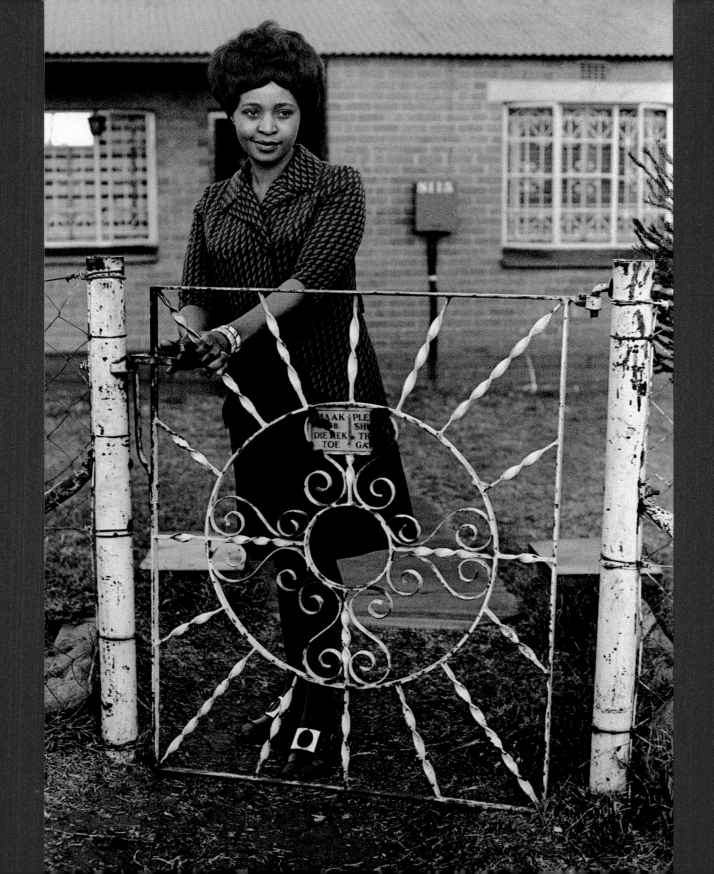

Winnie Mandela stands at the
old gate of 8115 during her
1974 banning order.

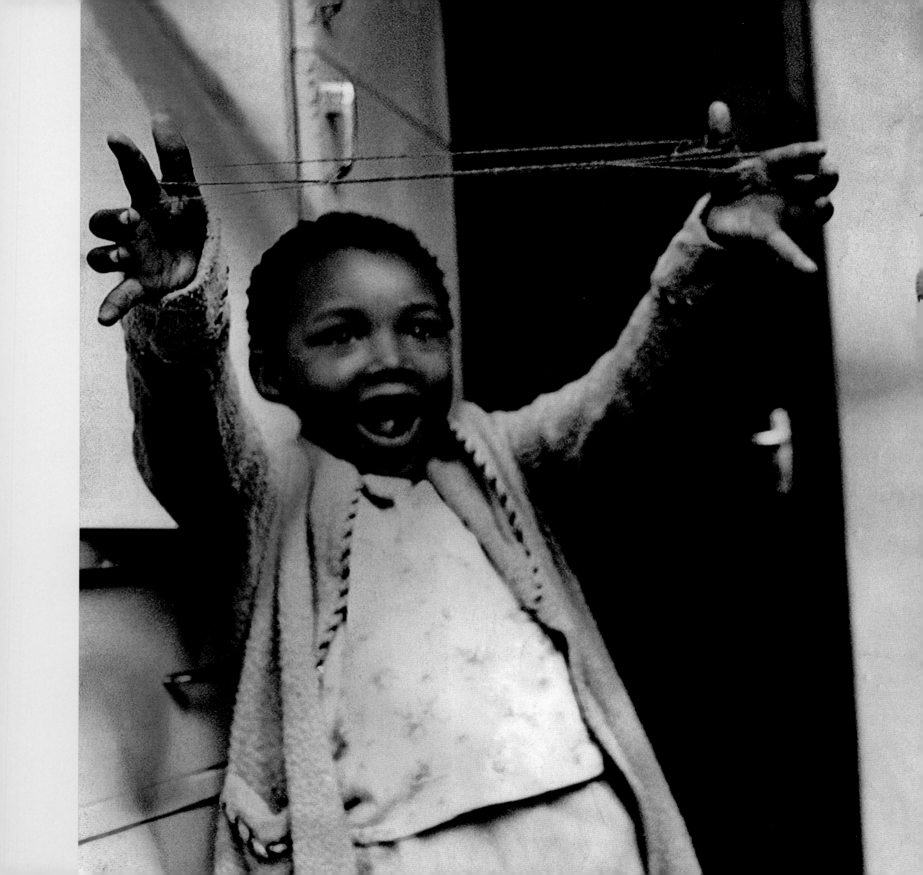

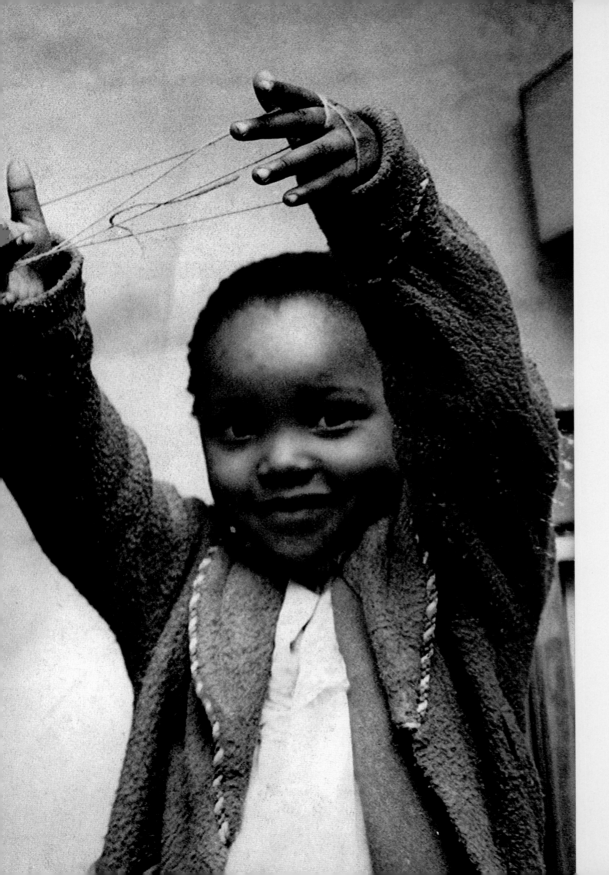

Zenani (left) and Zindzi (right) playing a game with string ('cat's cradle', perhaps) which was popular with children at the time. Nelson Mandela's daughters were not able to visit their father in prison until the age of sixteen. They were later to be sent to school in Swaziland, no doubt a difficult and lonely decision for their mother, but her children had been hounded out of other schools, or harassed by principals, making it impossible for them to be educated in South Africa.

Winnie Mandela in 1974 after serving a six-month prison sentence in Kroonstad Prison. She and renowned photographer Peter Magubane were both sentenced to six months' imprisonment after breaking their banning orders by communicating with each other.

Back home at 8115 after six months in Kroonstad Prison in 1974, Winnie strokes her dog.

Zindzi, Zenani and the family dog.

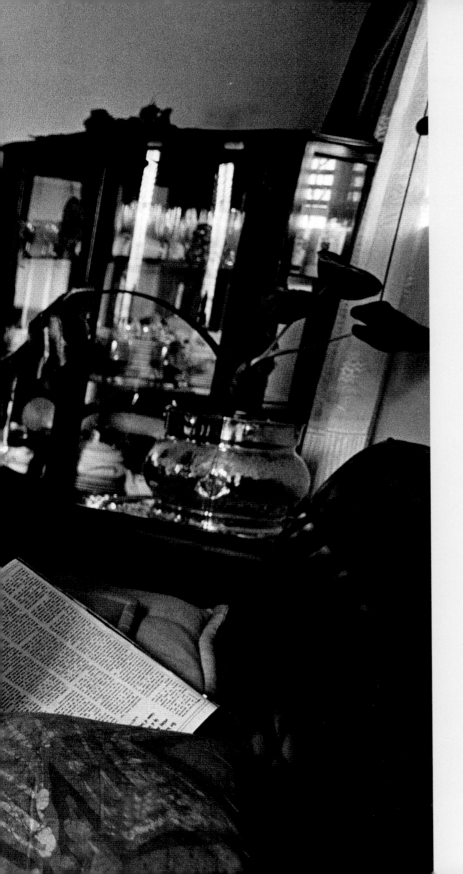

Zindzi and Zenani read a message from their
father imprisoned on Robben Island.

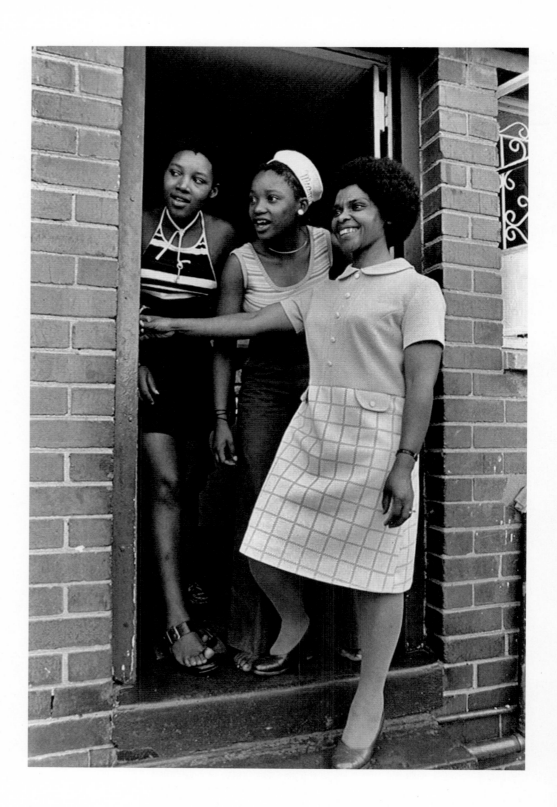

Zindzi and Zenani with their aunt
Nobantu Mniki, Winnie Mandela's
sister.

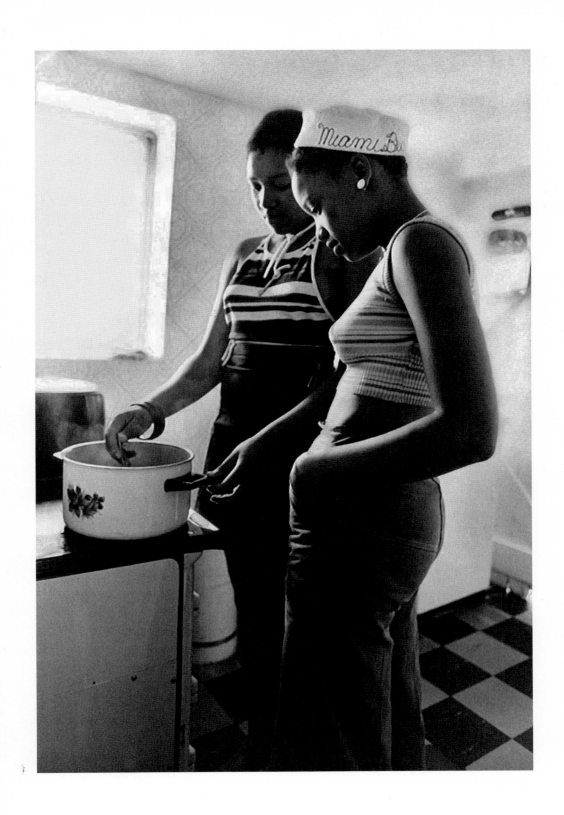

Zindzi and Zenani cooking in the kitchen at 8115.

PRISONERS IN OUR OWN HOME

Zenani and Zindzi looking through the gate
of 8115. This is one of the pictures that were
specially commissioned for Nelson Mandela
by his wife. The images were sent to Mandela
on Robben Island so that he could see how
his daughters were growing up.

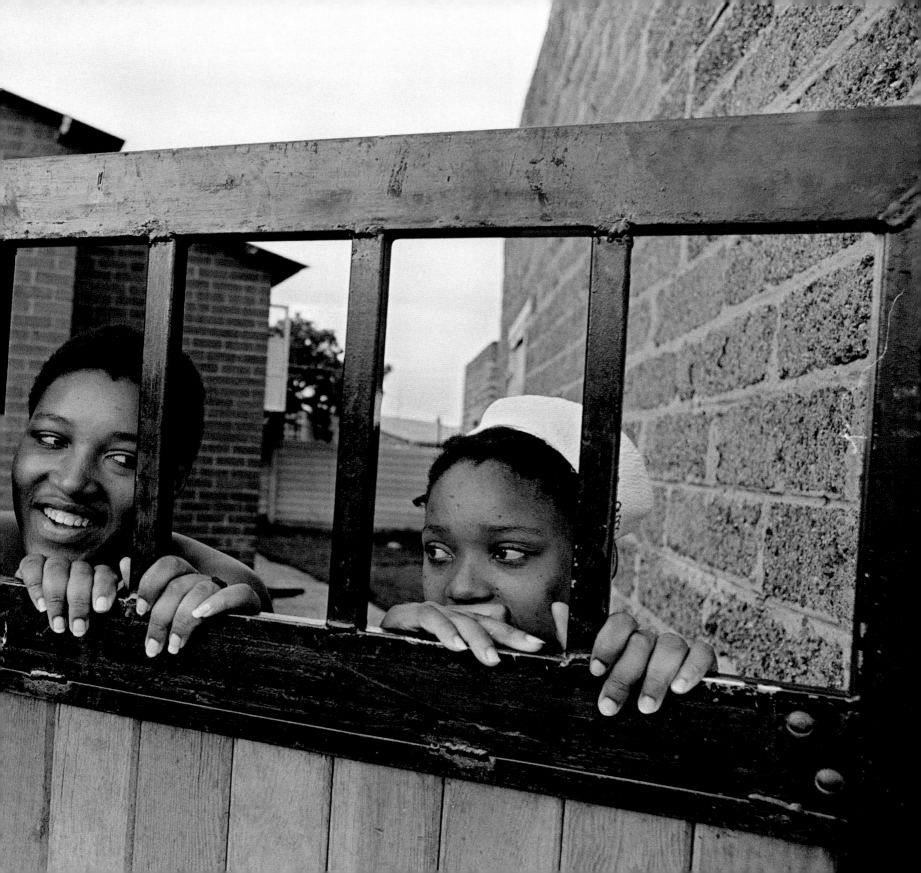

Zenani holding her father's Jawaharlal Nehru Award for International Understanding. The award was made by the Indian government in 1979 in recognition of Nelson Mandela's 'outstanding contribution to the promotion of international understanding, goodwill and friendship among peoples of the world'. The government refused to grant Winnie a passport to enable her to travel to India to accept the award on behalf of her husband. Zenani, who had a diplomatic passport by virtue of her marriage to the Swazi Prince Thumbumuzi Dlamini, went to India with her husband to receive the award on her father's behalf.

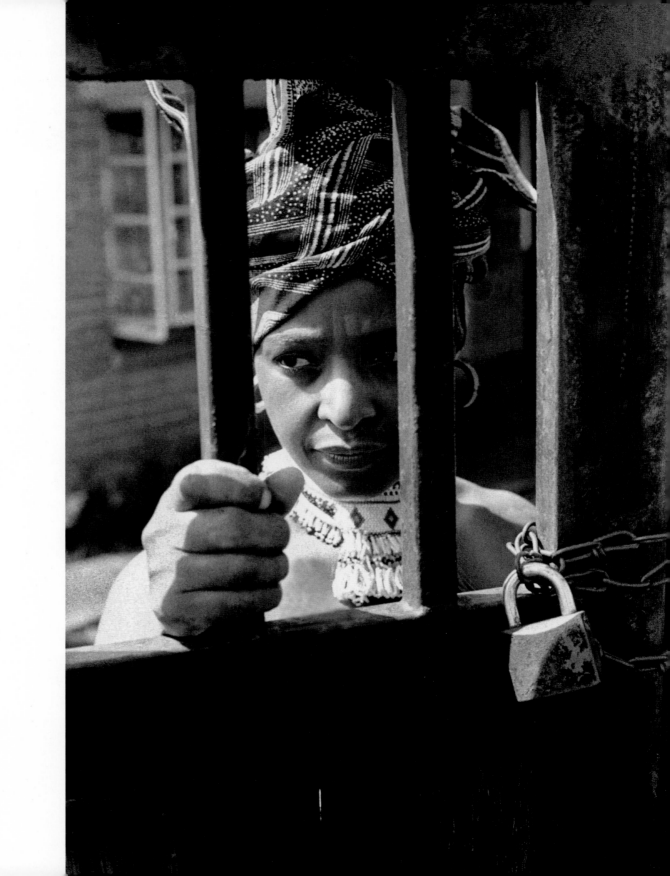

Winnie Mandela looks out of the gate of her home while she was under house arrest.

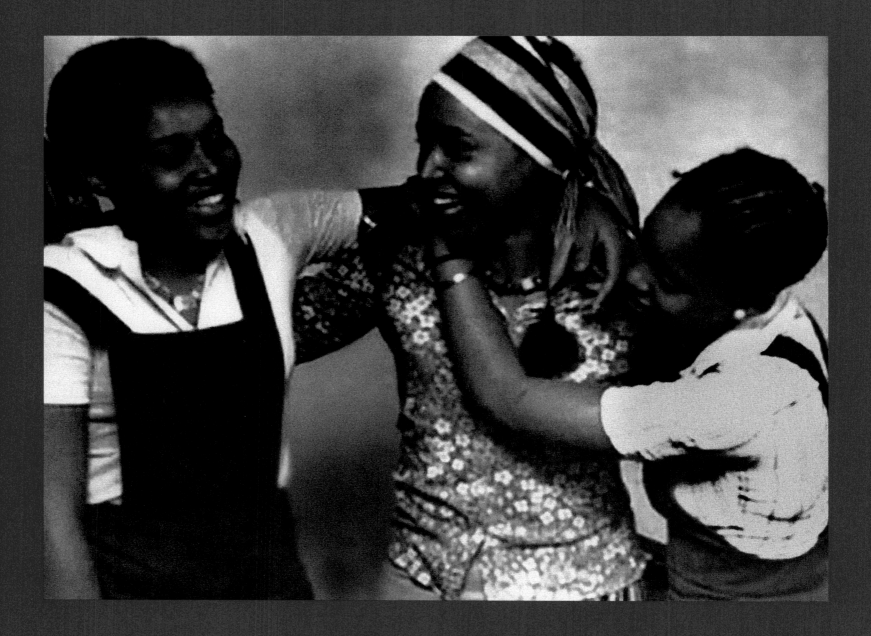

Winnie Mandela shares a laugh with her
daughters Zenani and Zindzi.

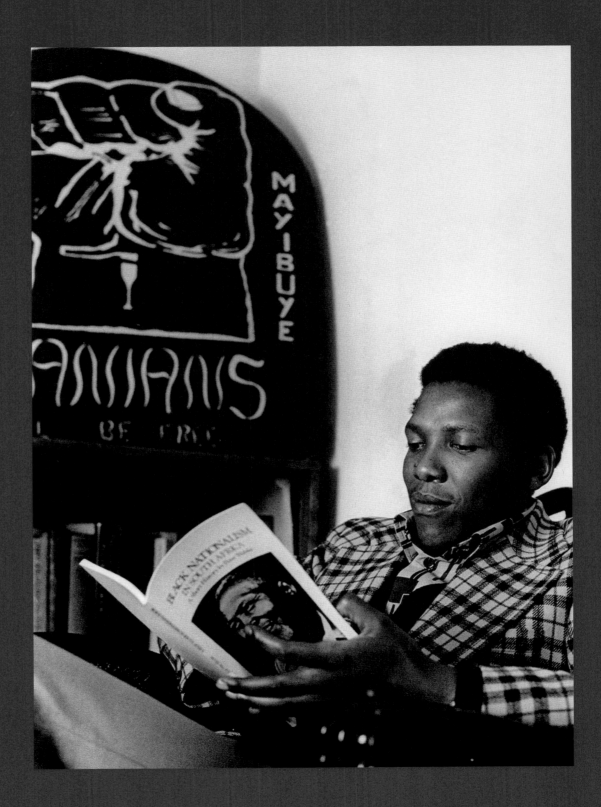

Nelson Mandela's younger son Makgatho in 1978. He is reading *Black Nationalism in South Africa: A Short History* by Peter Walshe. The hardboard in the background, depicting a clenched fist and the word 'Mayibuye' (an African freedom cry literally meaning 'come back'), was created by Tokyo Sexwale who found refuge at 8115 in the aftermath of the 1976 student uprising in Soweto.

Police and soldiers outside 8115 on 16 May 1977, the day Winnie Mandela was taken to Brandfort. Her banishment was initially to be for four years, but in fact Winnie spent nine and a half years in the small town in the Orange Free State. The conditions of her banishment were so stringent that she was allowed no visitors. In the foreground of the photograph wearing a light coloured dress is Winnie's sister Nonyaniso and on the far left is photographer Peter Magubane.

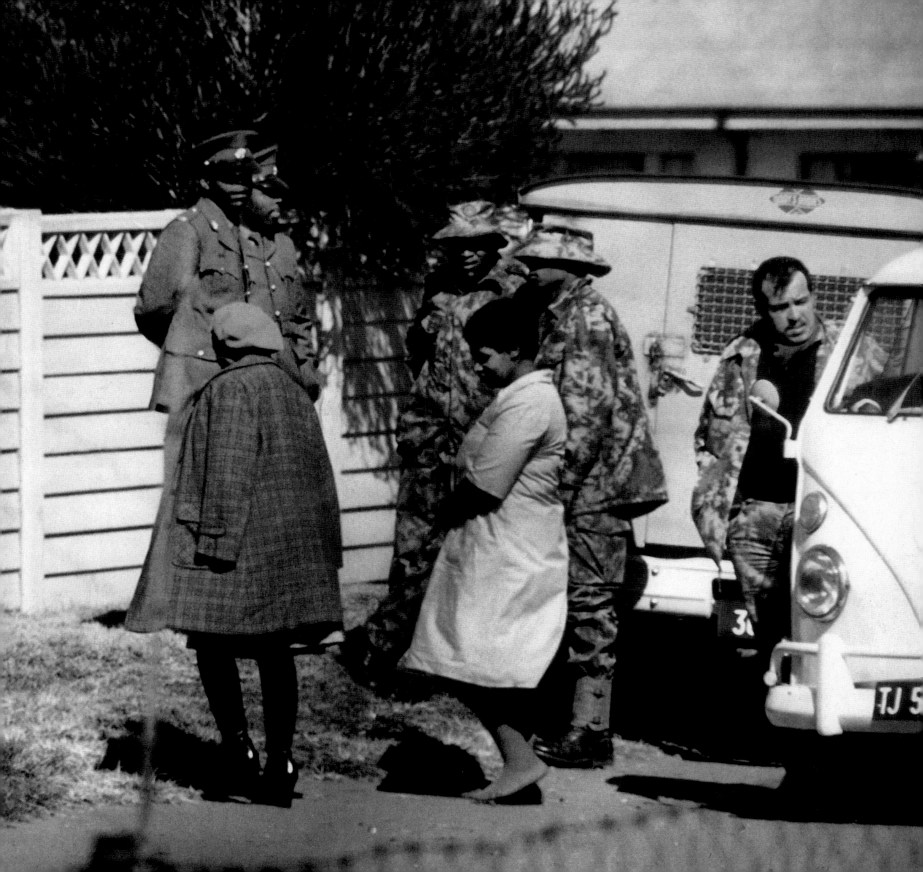

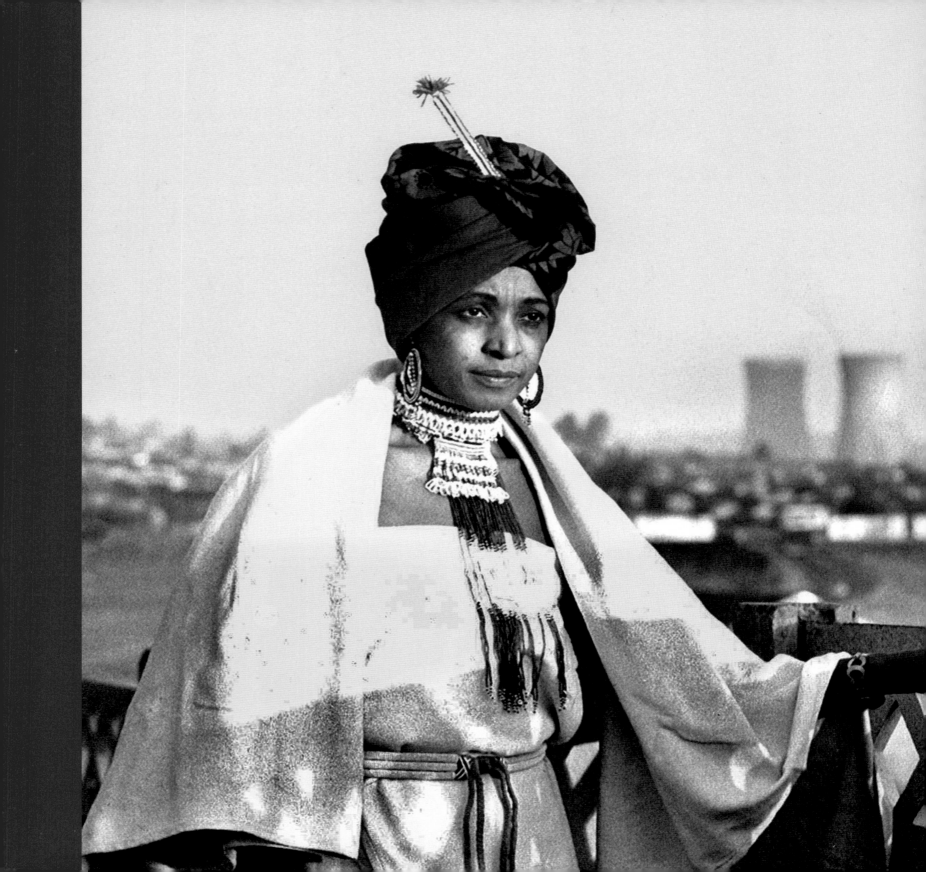

Wearing traditional dress, Winnie stands at
the gate of 8115. The famous Orlando cooling
towers can be seen in the background.
Although no longer in use, the towers remain
the largest landmark in Soweto.

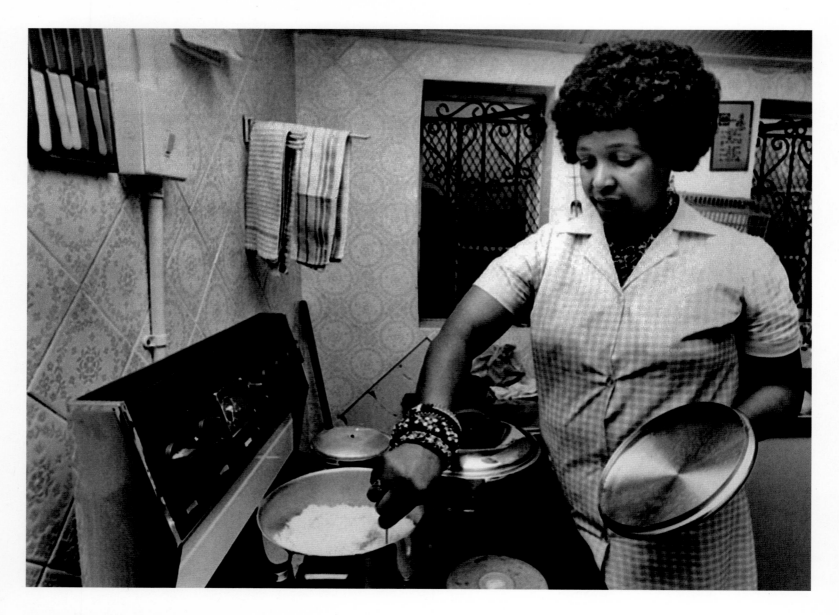

Winnie preparing a meal in the kitchen at 8115. Her
curry, which she had been taught to make by Indian
friends, was a favourite in the Mandela household and
much loved by her husband.

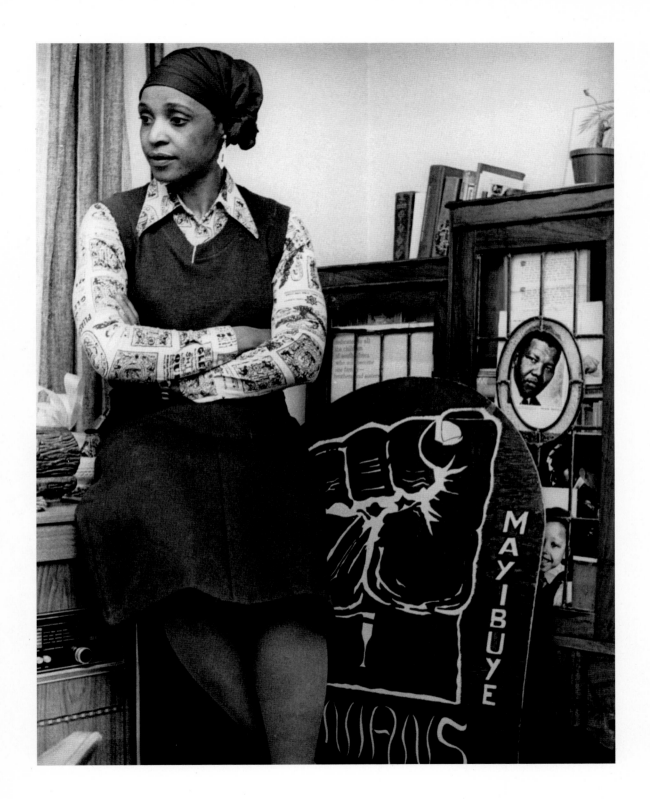

Winnie at home. Behind her is the
Mayibuye hardboard which was created
by Tokyo Sexwale when he stayed in
the house. Over the years 8115 was a
place of refuge for a number of activists,
including Penuell Maduna who later
became a minister in the governments
of both President Nelson Mandela and
President Thabo Mbeki.

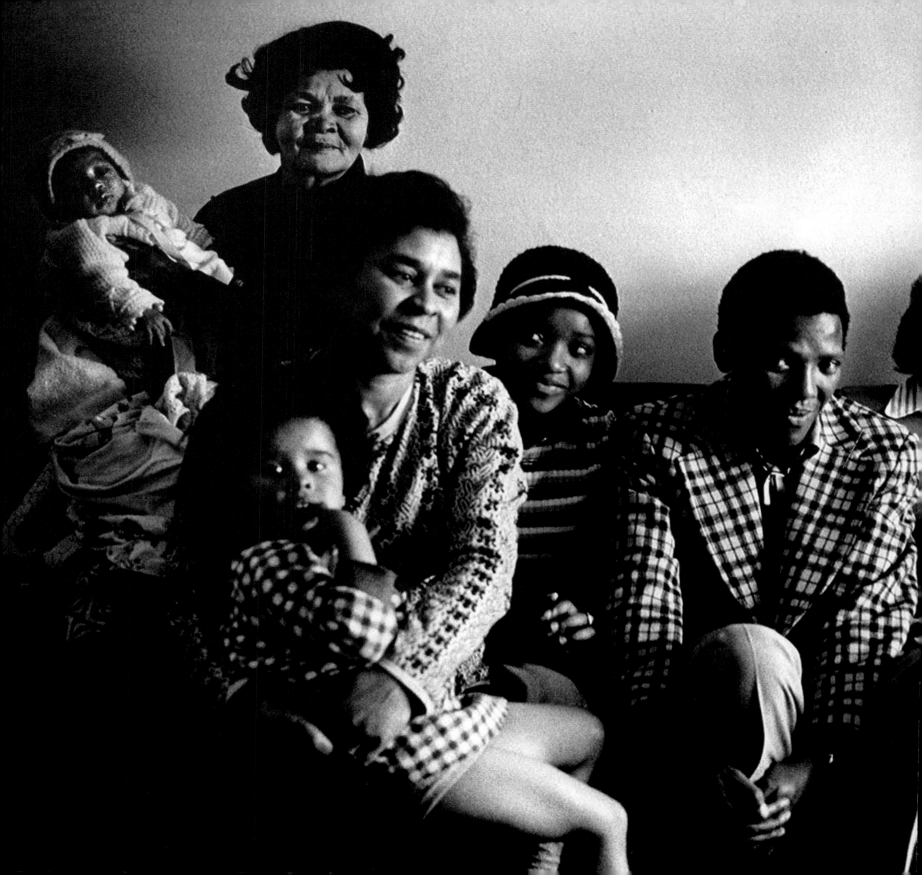

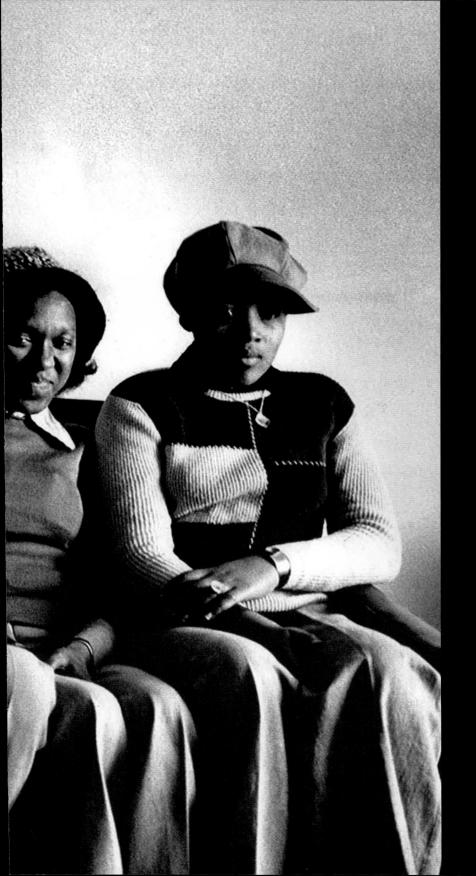

In this rare family portrait Makgatho Mandela,
second son of Nelson Mandela and his first
wife Evelyn, is surrounded by his three sisters,
Zindzi, Makaziwe and Zenani
(from left to right).

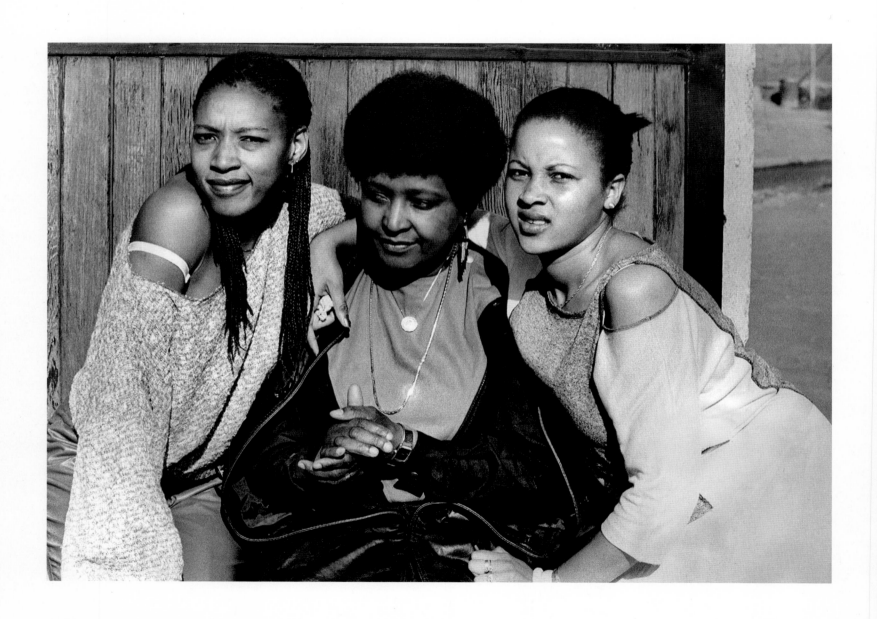

Zenani, Winnie and Theresa, a friend of Zenani's from
Swaziland in 1985. Both Zenani and Zindzi were educated at
the multiracial Waterford Kamhlaba College in Swaziland.

Winnie with the Reverend Phehlo in the 1970s.

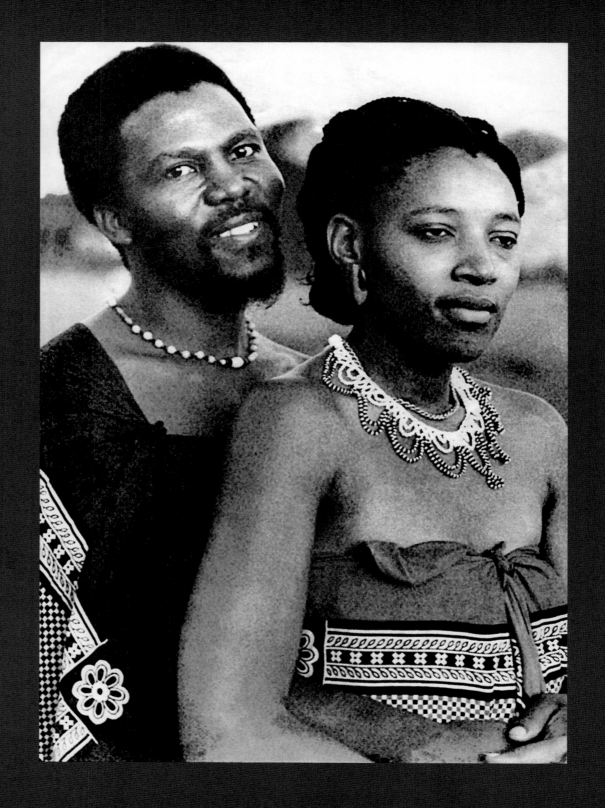

1977 picture of Zenani and her former husband, Prince Thumbumuzi Dlamini. The prince is the older brother of King Mswati III of Swaziland.

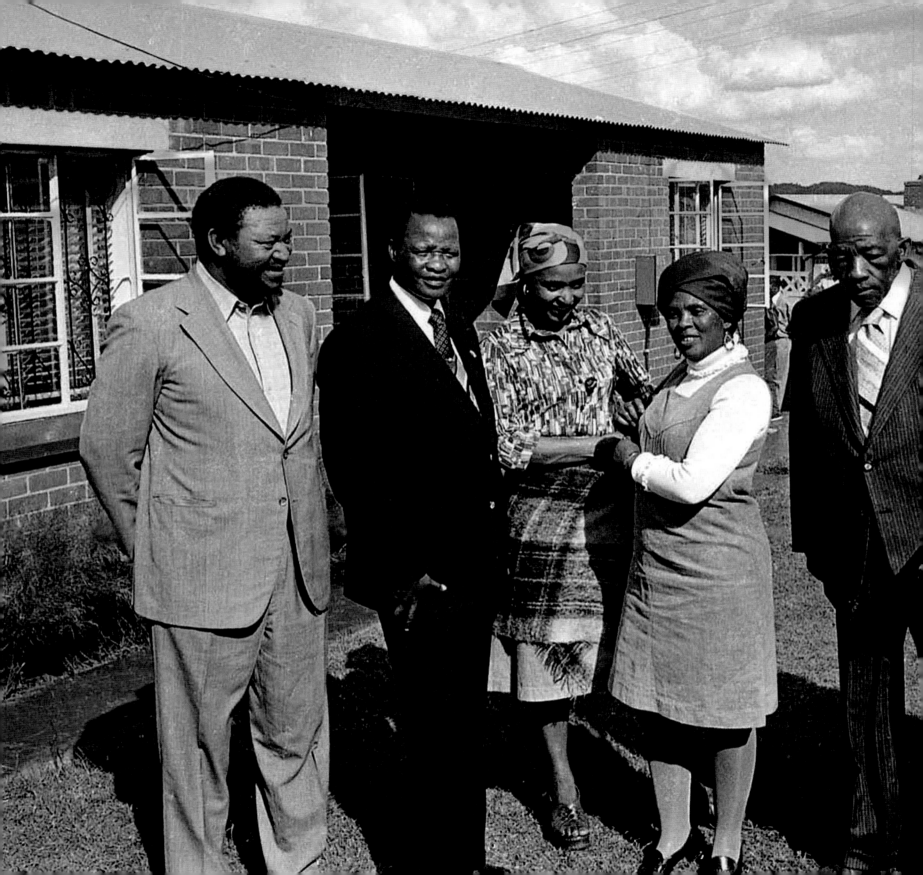

Prince Thumbumuzi Dlamini travelled to
8115 in 1977 to formally ask for Zenani's hand
in marriage. A number of family members
represented the Mandelas at the lobola
negotiations. From left: Winnie Mandela's
brother-in-law Gilbert Xaba, 'homeland'
leader and Nelson Mandela's nephew
K D Matanzima, Winnie, Mrs Dotwana, Chief
Mdingi, Dr Dotwana, Winnie's sister Nikiwe
Xaba and Principal Mzaidume.

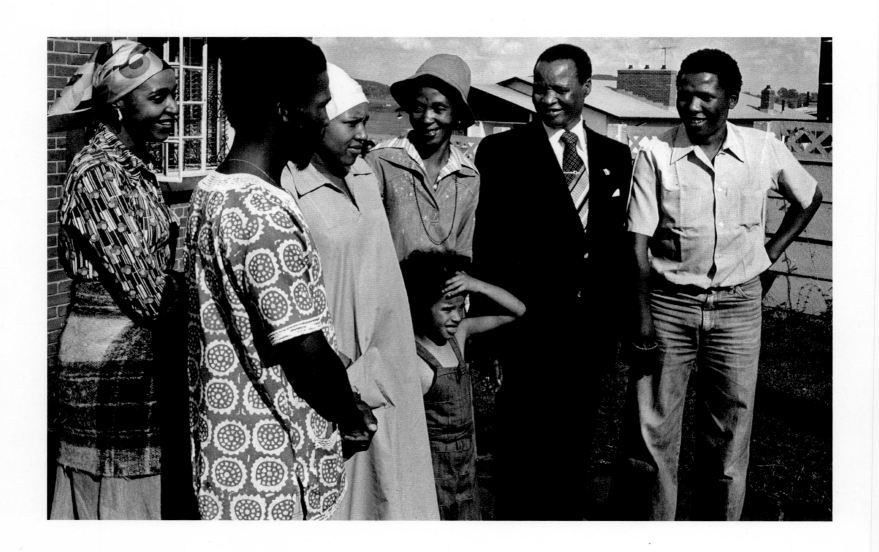

At the lobola negotiations for Zenani in 1977.
From left: Prince Thumbumuzi Dlamini, Zenani,
Makgatho's first wife Rennie, K D Matanzima and
Makgatho. Winnie Mandela is standing behind her
daughter and future son-in-law.

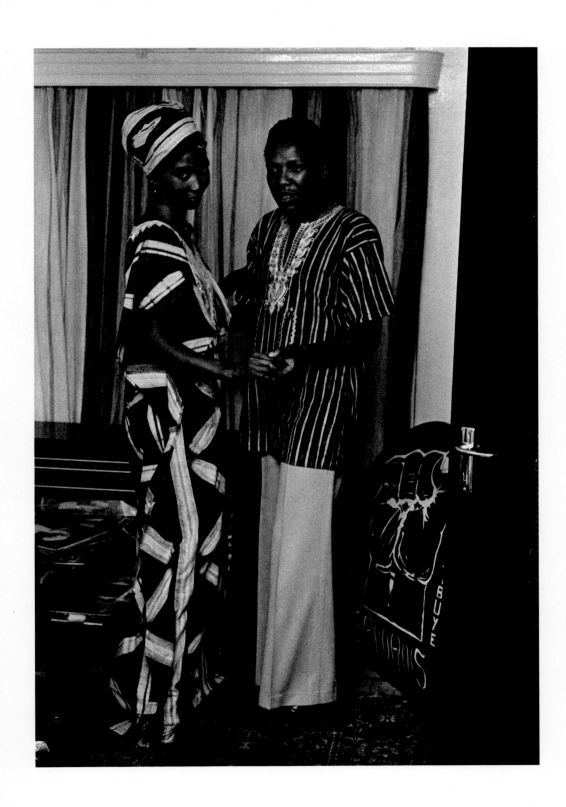

Makgatho and his first wife Rennie
on their wedding day.

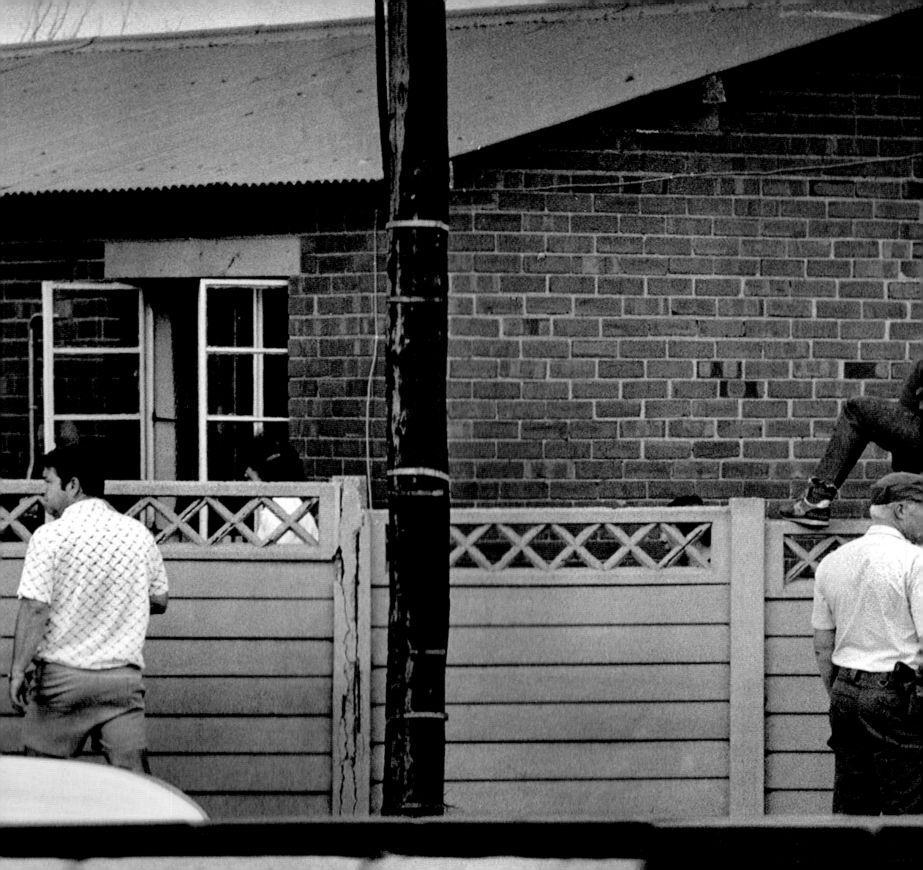

Climbing the wall, 21 December 1985: a raid at 8115 during the state of emergency declared by President P W Botha after the ANC president in exile, Oliver Tambo, called on South Africans to render the country ungovernable. Tambo's call came in the wake of the bombing of ANC bases in Botswana, Zambia and Zimbabwe by the apartheid government. The *Sunday Star* was the only newspaper willing to publish this photograph.

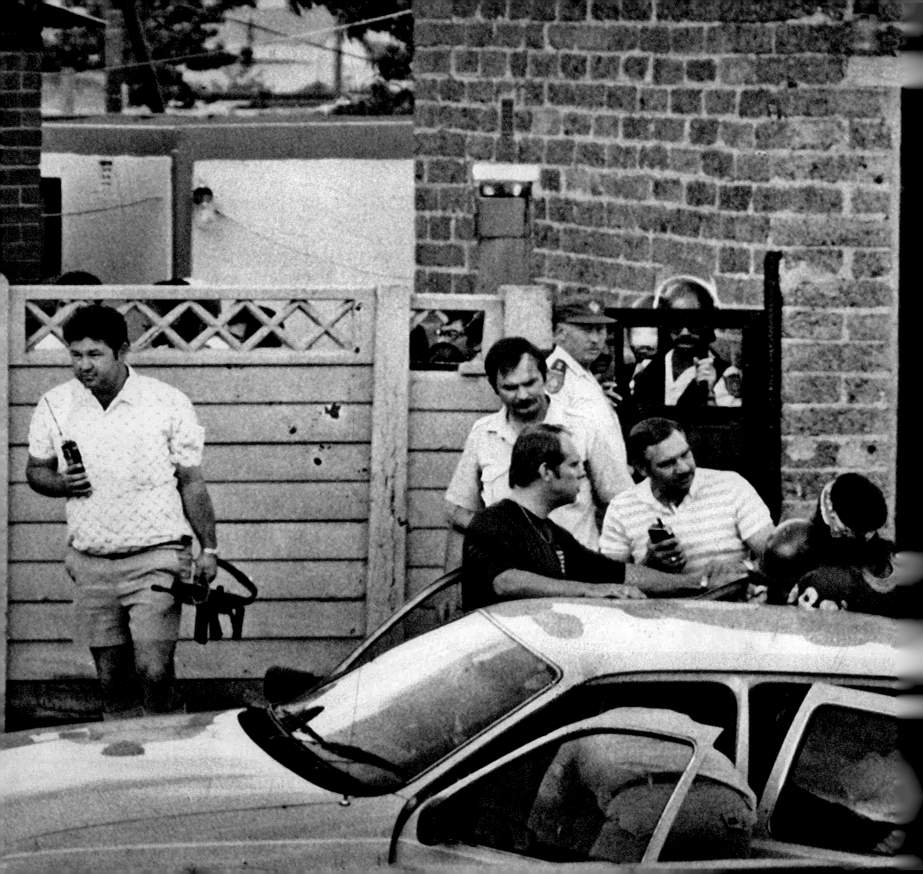

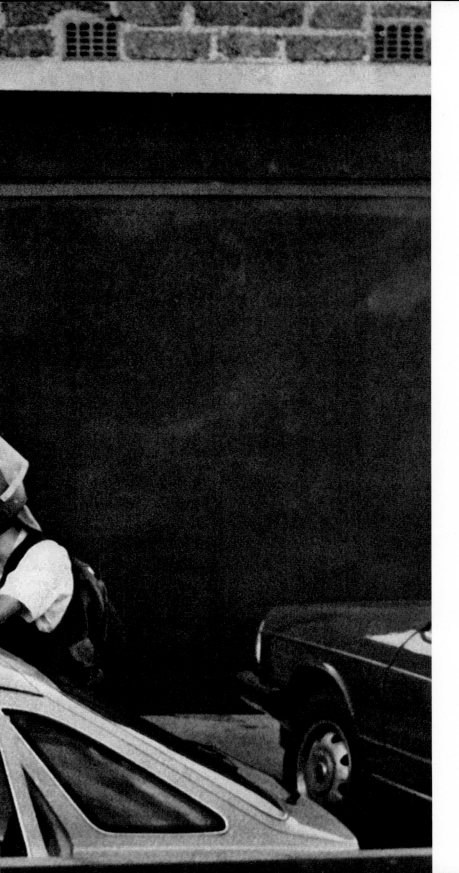

21 December 1985: Winnie Mandela is detained by the police yet again, this time outside 8115. She was restricted to Brandfort at the time but had returned home to Soweto in defiance of her banning order.

March 1986: Winnie Mandela being interviewed by journalist
Jon Qwelane. Alf Kumalo and Jon Qwelane were assigned to
cover a story on Winnie Mandela after lawyers representing
The Star newspaper found loopholes in the banning order that
restricted her to the town of Brandfort. The story was front
page news in the *Sunday Star*.

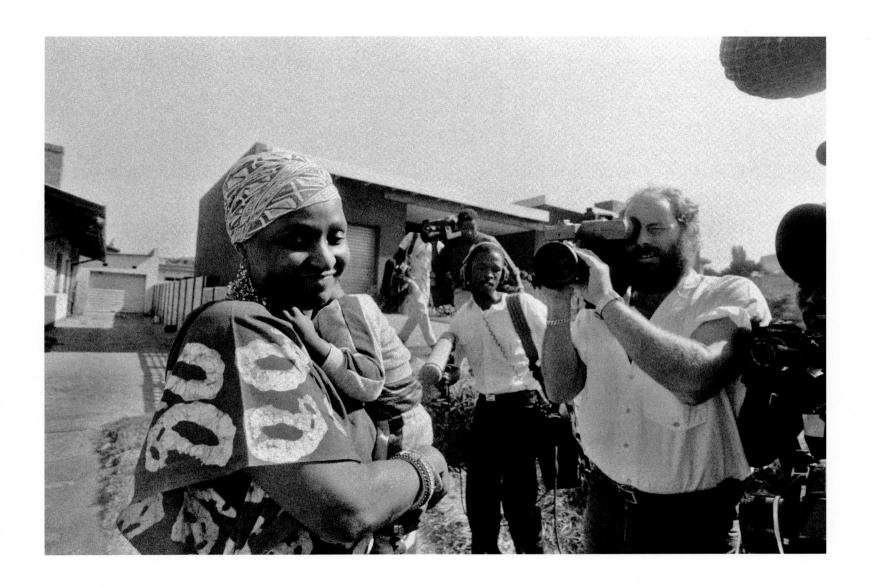

Winnie Mandela, holding her grandson Gadaffi, is interviewed by the media outside her home.

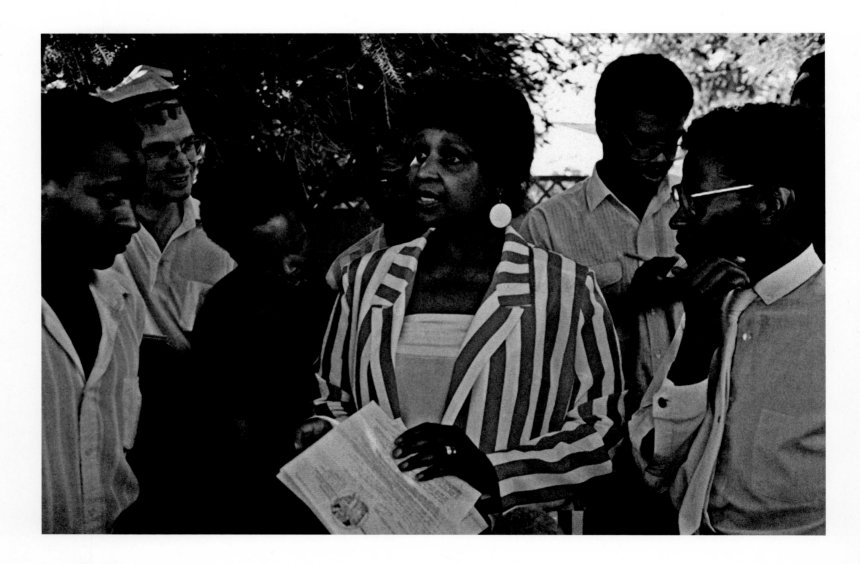

Winnie Mandela talking to South African journalists. On her left is Seth
Mazibuko, one of the leaders of the 1976 Soweto student uprising. He was
detained by the police and, at age sixteen, was sentenced to five years'
imprisonment. Later he became chief executive of the June 16th 1976
Foundation which was formed to keep alive the memories and lessons of a
watershed moment in South African history

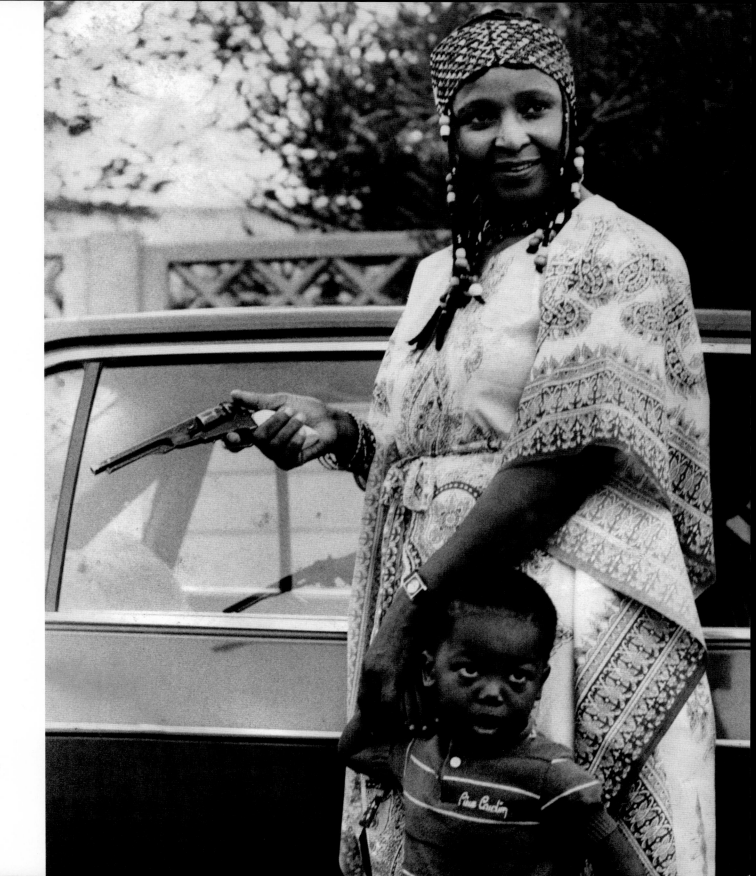

Winnie Mandela holds a toy gun while playing with her grandson.

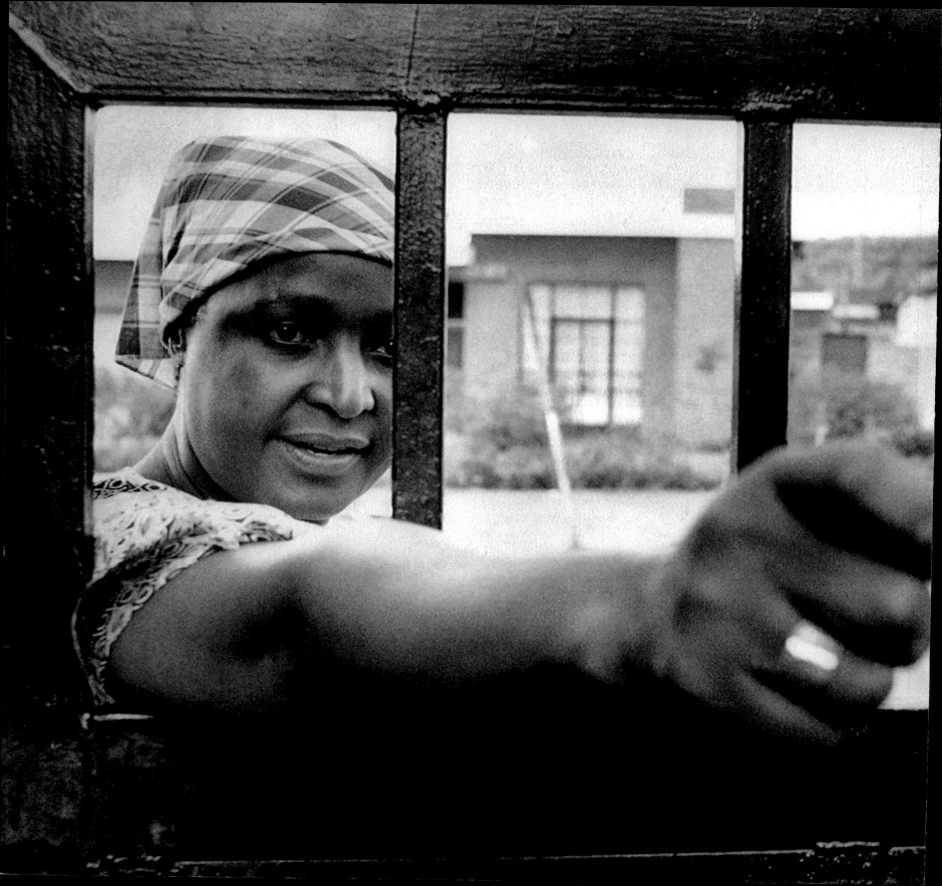

PRISONERS IN OUR OWN HOME

A rare moment of domesticity for Winnie Mandela as she changes the diaper of a relative's child. The photograph was taken during the 1980s.

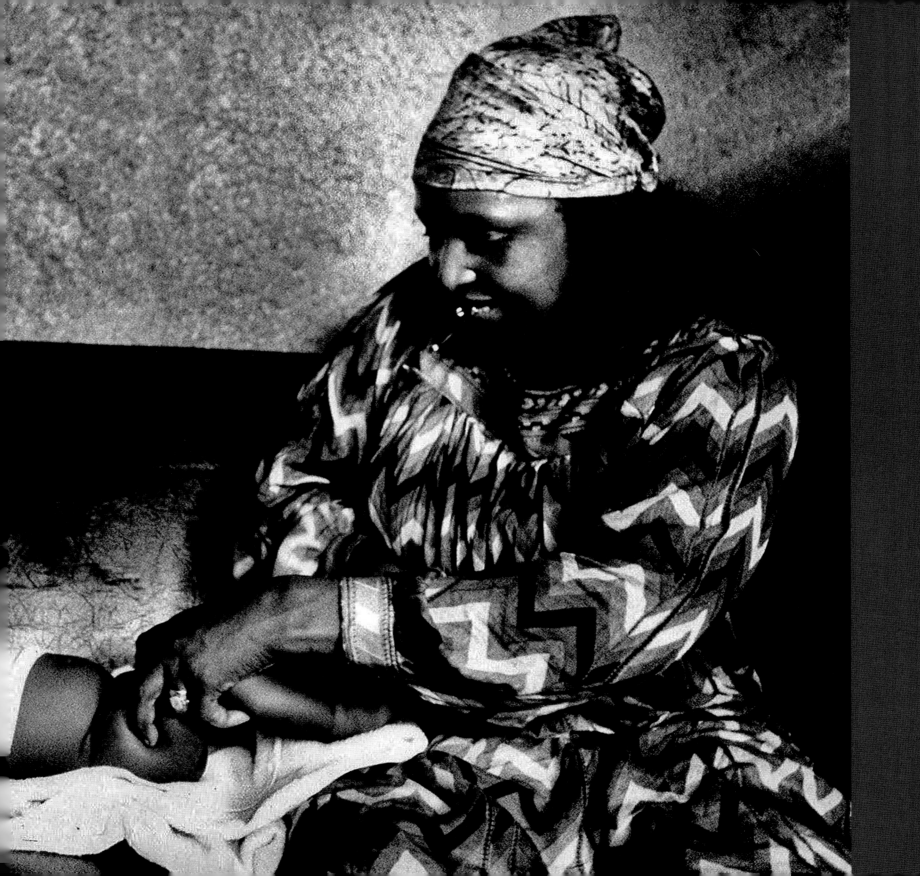

Winnie Mandela greets a broom seller outside 8115.

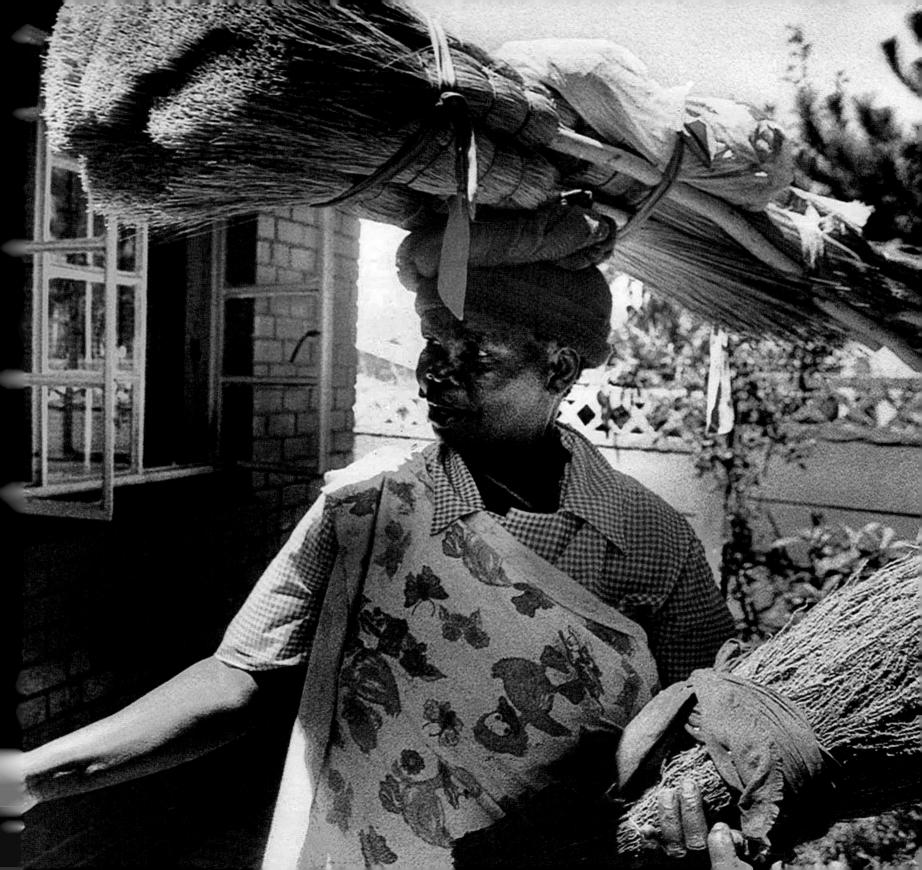

Zindzi's son Gadaffi, who was born in 1983.

Winnie Mandela and her
grandson Gadaffi. This picture
was taken during the 1980s.

Zindzi Mandela and her daughter Zoleka
who was born in 1980.

Winnie Mandela and some of her grandchildren – Zondwa, Zamaswazi, Zoleka and Zaziwe.

Zenani with her nephew Mandla (known as Nkosi Zwelivelile since he was invested as Chief of Mvezo). Mandla, who is the son of the late Makgatho Mandela, was born in 1974. A graduate of Rhodes University, he is the chief of the Mvezo Traditional Council and has been an ANC member of parliament since 2009.

Winnie Mandela and granddaughter.

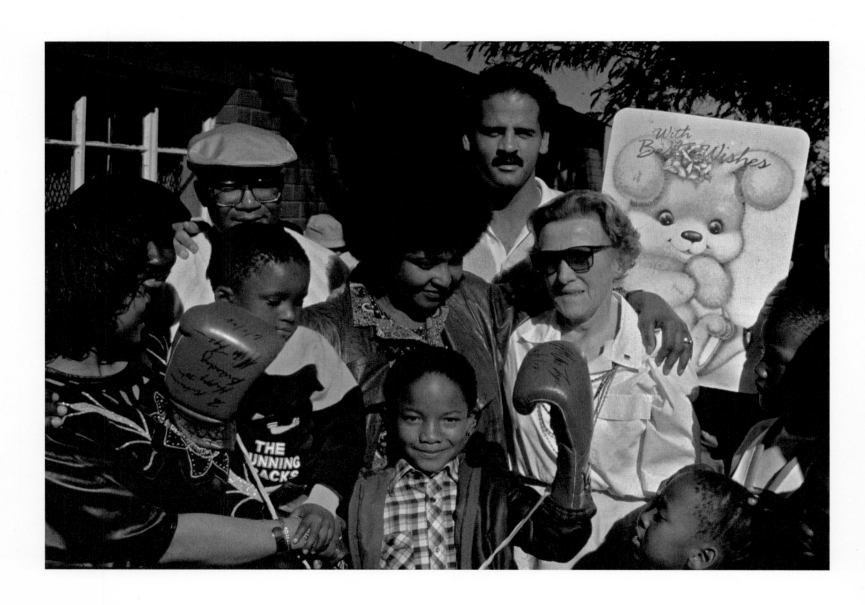

18 July 1988: Winnie Mandela, Zindzi and Gadaffi show off the signed boxing gloves given to Nelson Mandela for his seventieth birthday by world heavyweight boxing champion Mike Tyson. Mandela was an enthusiastic amateur boxer in his younger days.

Winnie Mandela marks Nelson Mandela's
seventieth birthday in 1988. For the
celebration seven thousand postcards,
written by schoolchildren in the United States
of America and calling for Mandela's release,
were flown in and delivered to the house.

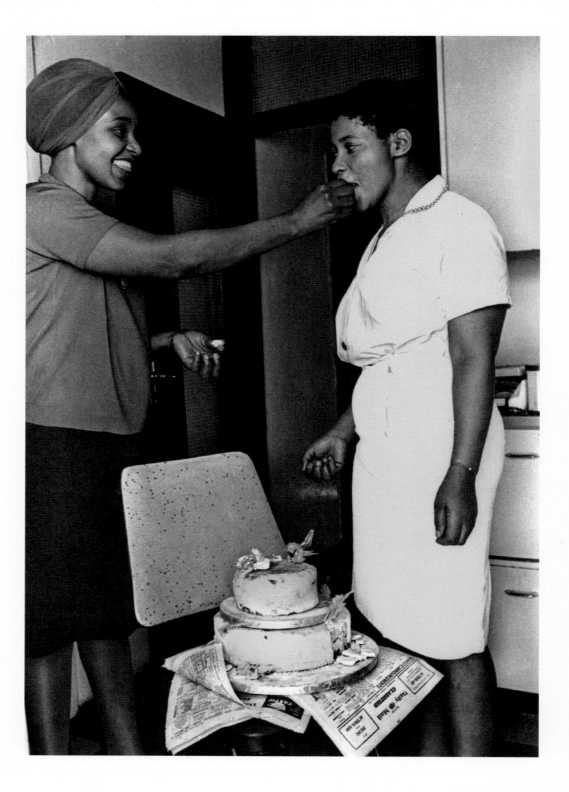

Winnie Mandela and her sister Nonyaniso share some icing from the top two layers of her and Nelson Mandela's wedding cake. As per their cultural tradition, part of the cake was saved so it could be eaten at the Mandela family homestead in the Transkei but as Nelson Mandela was, at the time of the wedding, banned and, later, imprisoned, this tradition could not be completed. Winnie kept these layers carefully wrapped and stored in her fridge until the 18th of July each year (her husband's birthday), when she would call a press conference at 8115 and display the cake for photographers and journalists. Winnie would occasionally dip a finger into the icing but would leave the cake relatively untouched. The cake would later be consumed by fire during Winnie Mandela's time at Brandfort after an arson attack perpetrated by security police.

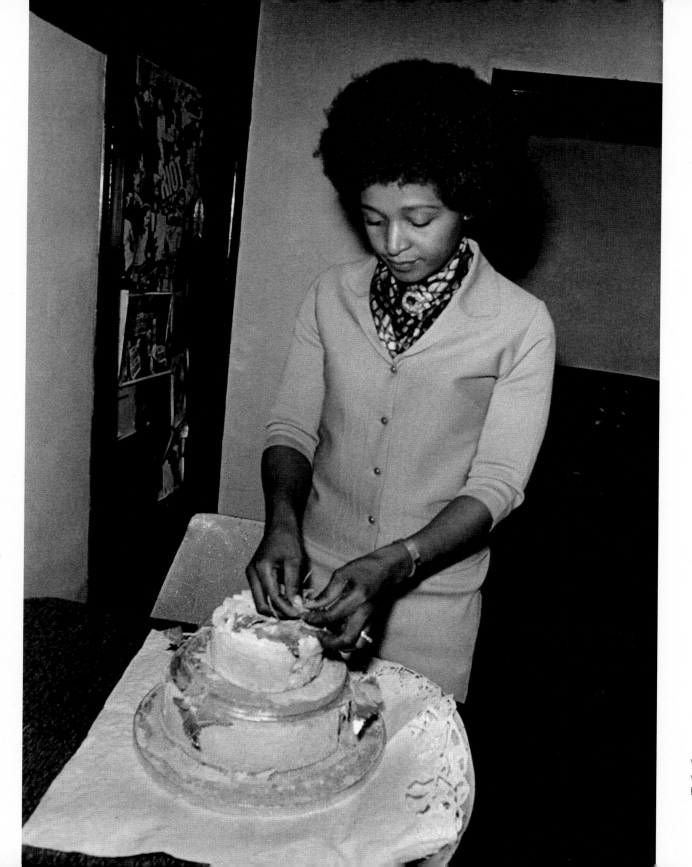

Winnie Mandela decorating
what remains of her and her
husband's wedding cake.

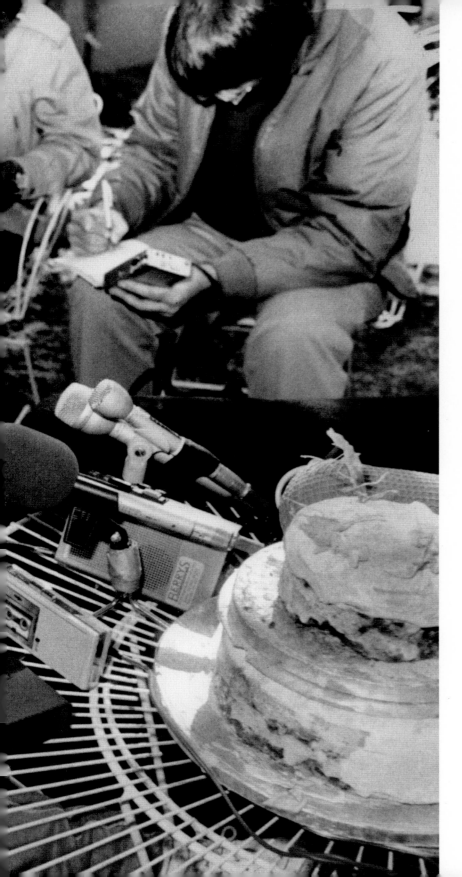

Winnie Mandela and grandsons during one
of the press conferences held on the 18th of
July, her husband's birthday.

113

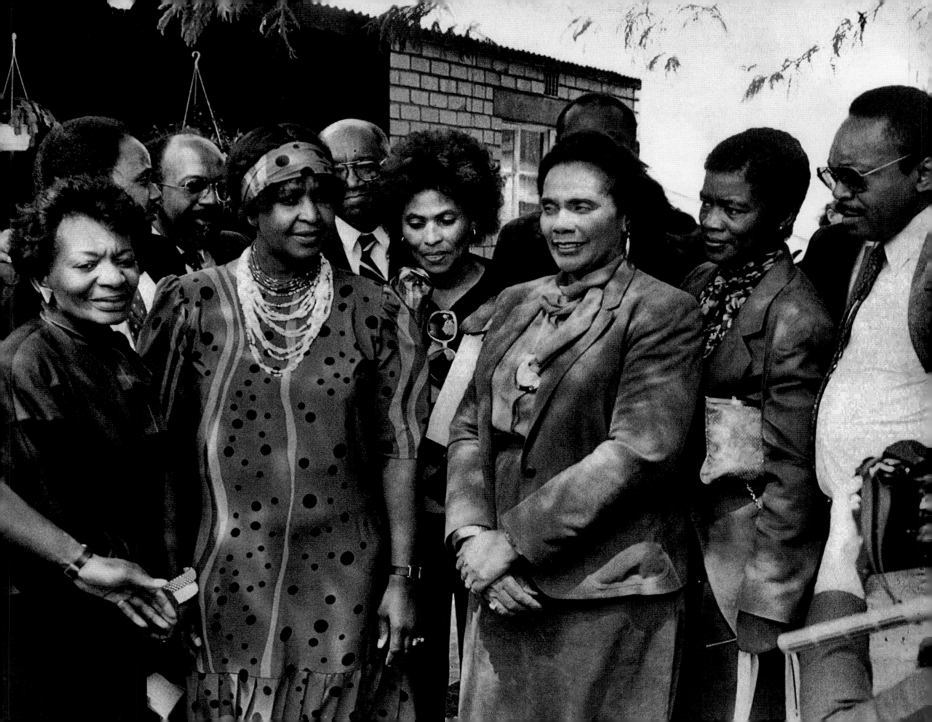

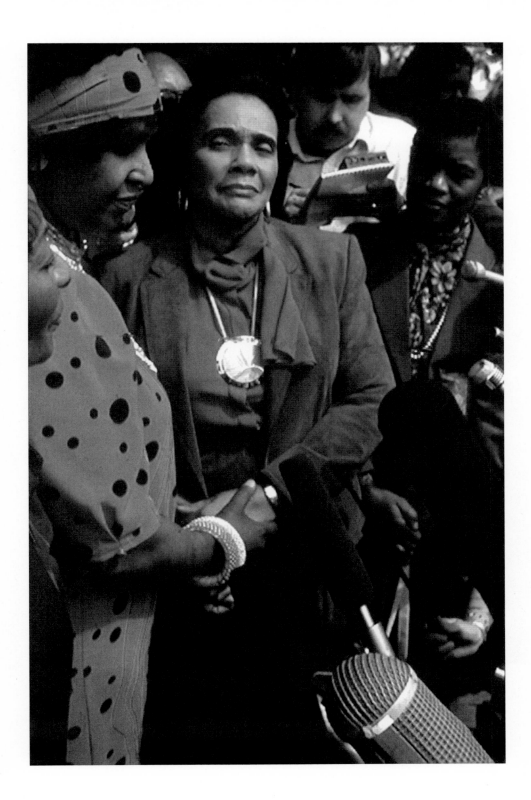

Winnie Mandela and Coretta Scott King, widow of slain African-American civil rights leader Martin Luther King, Jr, during a press conference at 8115 in 1986. On her return to the United States, Mrs King urged President Reagan to approve economic sanctions against South Africa.

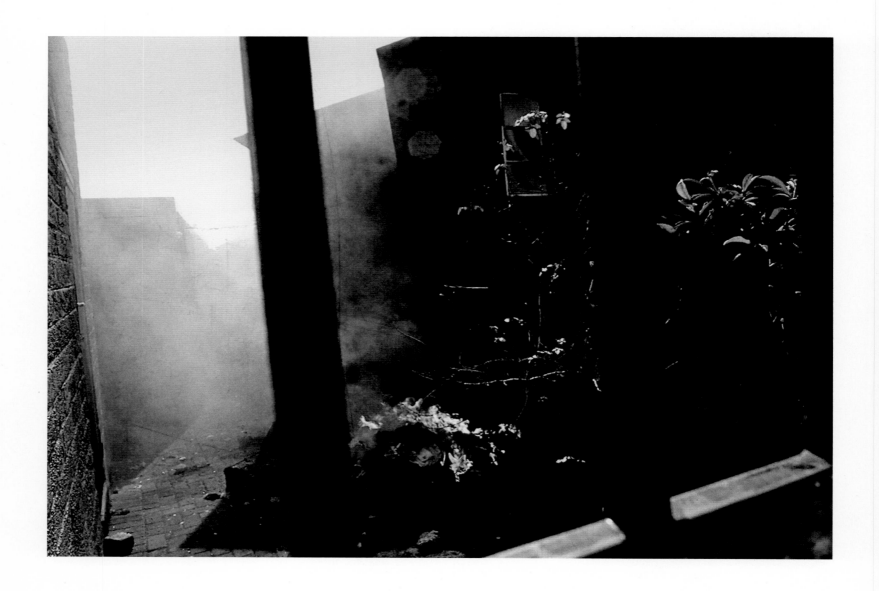

8115 after students from Daliwonga High School set it on
fire in 1988. The community rallied to help rebuild the house
which is now a South African heritage site and museum.

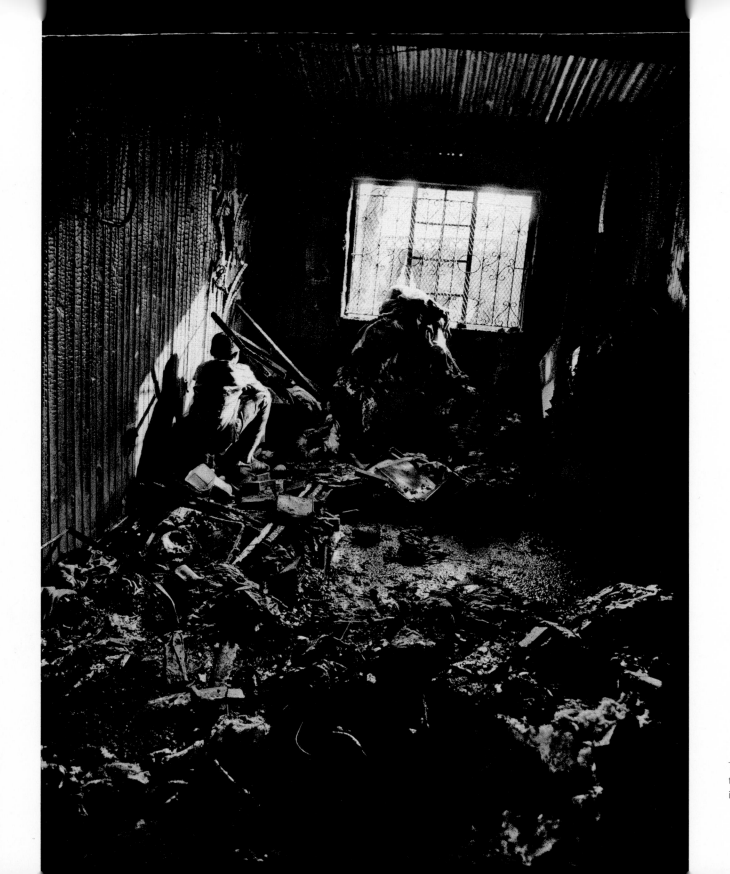

The devastation inside
the house after the fire
in 1988.

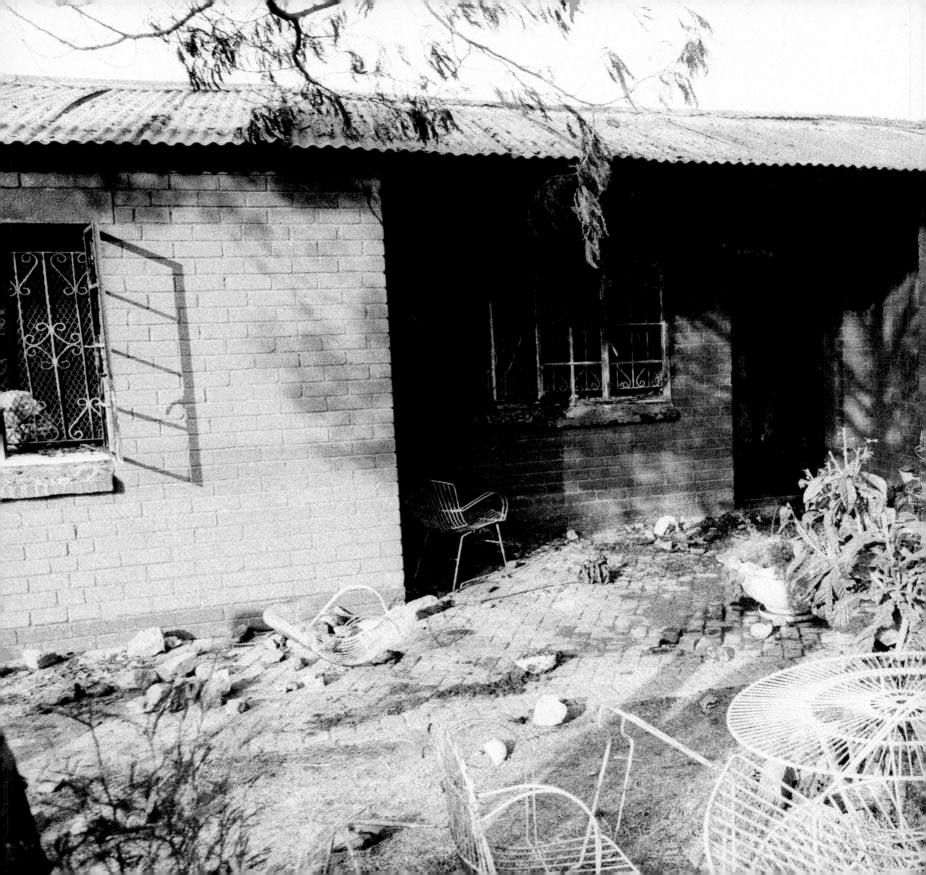

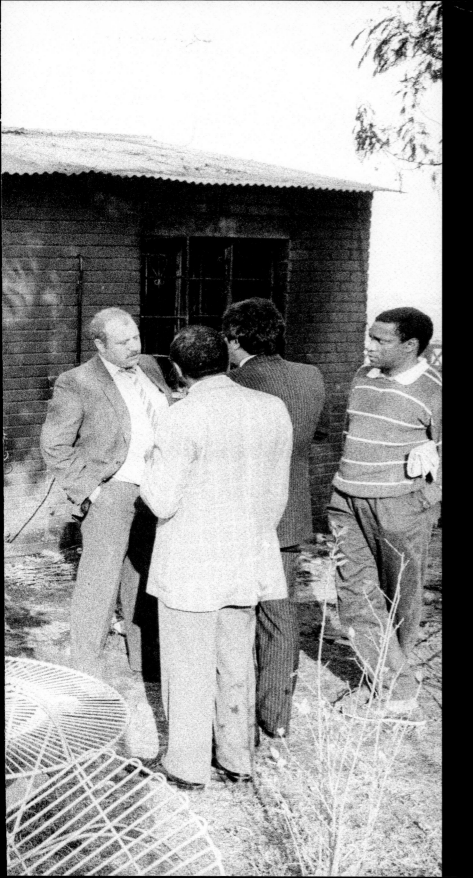

The courtyard behind 8115. On the right
are members of the police tasked with
investigating the incident.

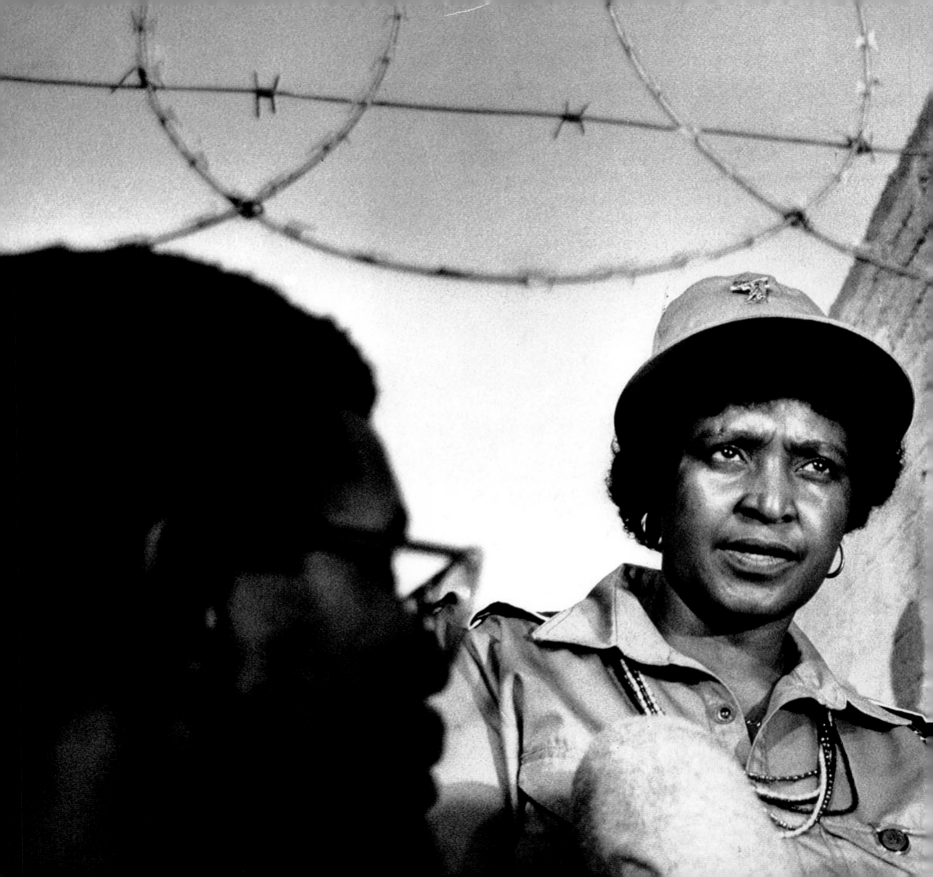

Winnie Mandela in military gear outside
8115 on 2 February 1990, the day
F W de Klerk unbanned political
organisations and announced that
Nelson Mandela would be released.

THE HOMECOMING
1990–2010

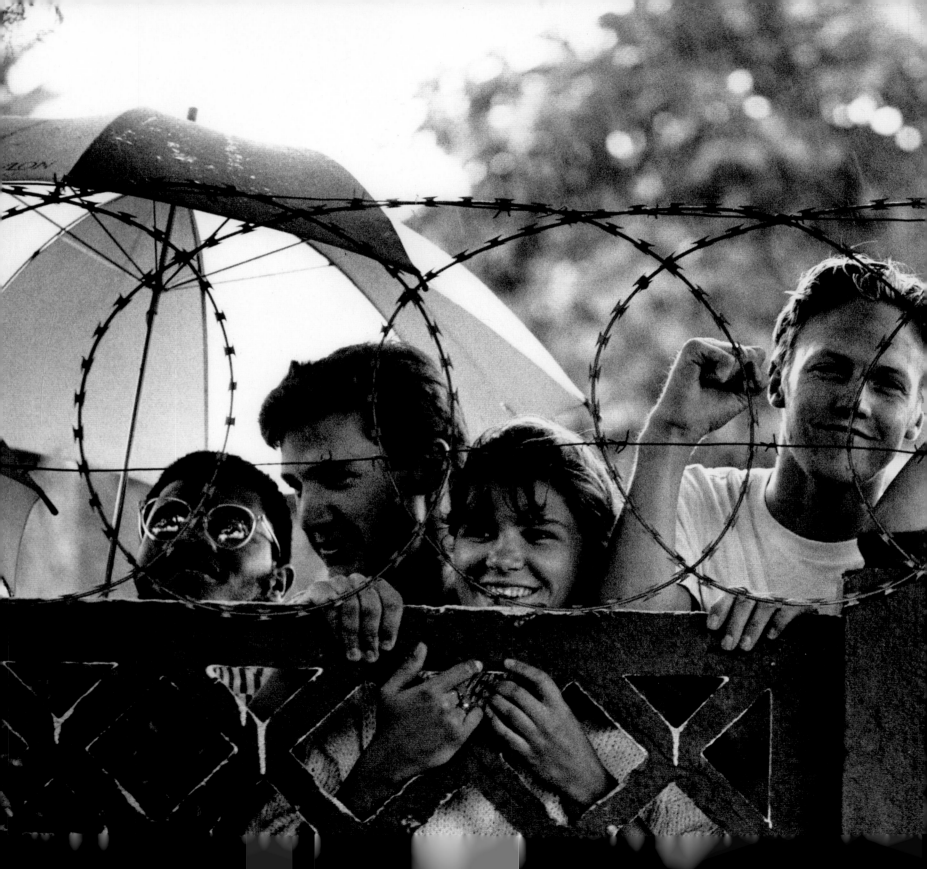

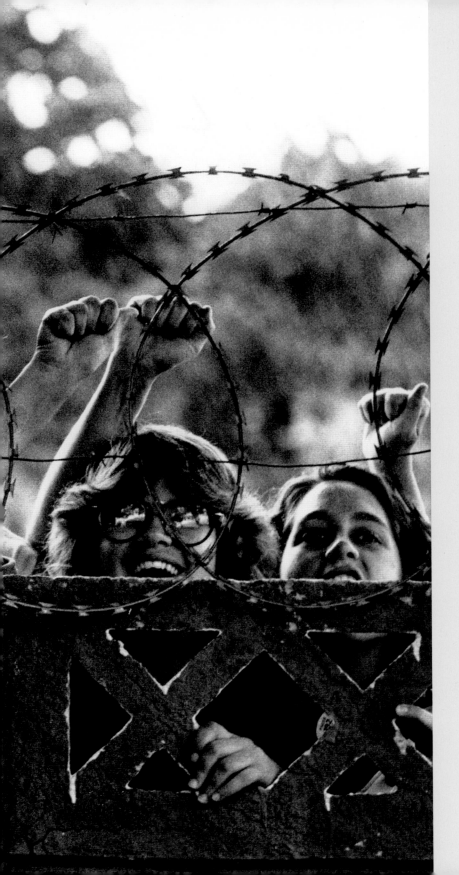

Tourists to Soweto peer over the wall of 8115 hoping for a glimpse of the world's most famous political prisoner. February 1990.

In 1985, after Zindzi had read the 'My Father Says' speech at a UDF rally, Nelson Mandela was diagnosed with an enlarged prostate gland and had to undergo surgery at Volks Hospital in Cape Town under heavy security. Winnie managed to fly to see him before the surgery but Mandela also received another visitor: Justice Minister Kobie Coetsee. Prior to this, Mandela had written Coetsee a letter about the possibility of talks between the ANC and the government, so Coetsee's visit appeared to be a favourable reaction to the suggestion of talks between the two parties.

On returning to prison from hospital, Mandela was given his own cell on the ground floor, three floors away from his comrades. No explanation was given. The other men could well have been in an entirely different place. In order to meet with them, Mandela had to make an application to visit and await a response from Pretoria. Within a few weeks of the move, he wrote another letter to Coetsee proposing they hold talks. Coetsee did not respond.

The world continued to watch South Africa. In January 1985 ANC president in exile Oliver Tambo called on South Africans to render the country ungovernable. In July 1985, in response to increasing cycles of violence in the Eastern Cape and on the East Rand, President P W Botha attempted to repress black opposition groups still further by imposing a state of emergency in thirty-six magisterial districts.

At a meeting in October 1985, Commonwealth leaders failed to agree on imposing sanctions against South Africa, largely because of British Prime Minister Margaret Thatcher's opposition. In *Long Walk to Freedom* Mandela writes: 'To resolve the deadlock, the assembled nations agreed that a delegation of "eminent persons" would visit South Africa and report back on whether sanctions were the appropriate tool' to end apartheid. The group, led by Olusegun Obasanjo, arrived in South Africa early in 1986. They visited Mandela in March 1986 to discuss their brief. Mandela told them that it was his sentiment, and not that of the ANC, that the time had come for negotiations between the government and the ANC.

In May, the Eminent Persons Group returned to South Africa for further talks, but the day before they were to meet Mandela the apartheid government bombed ANC bases in Botswana, Zambia and Zimbabwe, effectively putting a spanner in the works as far as negotiations were concerned. The Eminent Persons Group cut short their visit and left the country.

Violent protests from the black opposition continued and on 12 June 1986 the state of emergency was extended to the entire country.

But Mandela was still trying to negotiate. In June he wrote a letter to the commissioner of prisons asking to see him 'on a matter of national importance'. When the commissioner met him, Mandela requested a meeting with Coetsee. The commissioner made a phone call and the meeting with Coetsee was arranged. At the conclusion of their conversation, Mandela asked to see P W Botha and Pik Botha, respectively president and foreign minister. There was no response, but on Christmas Eve Mandela was taken for a drive through the city of Cape Town by the deputy commander of Pollsmoor, Lieutenant Colonel Marx. Thus began the excursions which would continue until Mandela was released from prison, to familiarise him with a world that he had been out of for too long.

In 1987, communications between Mandela and Coetsee resumed. The discussions included senior apartheid apparatchiks. Before the talks began, Mandela had individual meetings with his comrades upstairs. He briefed them on what had happened. Raymond Mhlaba and Andrew Mlangeni were in agreement that negotiations should begin. Walter Sisulu agreed, but with reservations, emphasising that he would have preferred it if the government had been the one to approach Mandela rather than vice versa. Ahmed Kathrada was the only one unequivocally opposed to the talks, but he indicated that he would not stand in Mandela's way if the older man thought it was the best action to take. Perhaps wanting to show goodwill even before the formal discussions began, the apartheid government released Govan Mbeki unconditionally in November 1987.

The first formal meeting took place at Pollsmoor in 1988. The most difficult issue to resolve was the ANC's continuation of the armed struggle which the National Party negotiators wanted suspended before continuing with talks. Another problematic area was the issue of majority rule because the apartheid government feared negotiating themselves out of power in a country where blacks far outnumbered whites.

The discussions were suspended when Mandela was admitted to Tygerberg Hospital in August 1988 where he was diagnosed with tuberculosis. On his discharge from hospital, Mandela was moved to the Constantiaberg Clinic. While he was there, Coetsee told him he was going to be moved to a 'situation that was halfway between confinement and freedom'.

And, indeed, in December he was once again taken to a new place – the place he would walk out of on 11 February 1990 – a house on a dirt road in Victor Verster Prison in Paarl which came with a warder who would cook for Mandela.

In January 1989, Mandela received a visit from his comrades at Pollsmoor and he updated them on the negotiations. While hoping to continue the discussions, fate stepped in and changed the course of events. That same month, P W Botha suffered a mild stroke and a month later he resigned as leader of the National Party, while retaining his position as state president. On 5 July, Mandela had his first meeting with P W Botha at Tuynhuys, the presidential office. It was to be the last meeting between the two men with Botha as state president. Yielding to pressures within his party, Botha resigned in August 1989 and F W de Klerk was sworn in as state president on 20 September.

On 10 October 1989, after less than two months in power, F W de Klerk announced the impending release of all the remaining Rivonia trialists, apart from Mandela. They were Walter Sisulu, Raymond Mhlaba, Ahmed Kathrada, Andrew Mlangeni and Elias Motsoaledi. Other political prisoners Wilton Mkwayi, Jeff Masemola and Oscar Mpetha were also on the list. The group was released on 15 October 1989. The Rubicon that P W Botha had not quite managed to cross with the release of

Govan Mbeki in November 1987 was now finally being crossed. F W de Klerk arranged for a meeting with Mandela in December 1989. By this time he had been permitted to meet with his newly released colleagues and was able to plan how best to go forward with discussions. When he met De Klerk at Tuynhuys, Mandela's major concern was the newly introduced five-year plan containing the concept of group rights. He emphasised that he felt this was just a way of maintaining white domination under the guise of protecting minority rights. It would be an issue that would hold up negotiations, but in his State of the Nation address on 2 February 1990, President F W de Klerk legalised all previously banned political organisations and announced that Mandela would be released.

On 9 February, Mandela was yet again taken to Tuynhuys and it was then that the president informed him that he would be released in Johannesburg on 11 February. Mandela asked that he be released seven days after that date so that his family and organisation could prepare for his release. He also insisted on being released from the gates of Victor Verster Prison, rather than in Johannesburg. De Klerk would not be moved on a postponement, but agreed to his release from the prison gates.

Shortly before four o'clock on the afternoon of Sunday 11 February 1990, Nelson Mandela walked out of Victor Verster Prison, hand in hand with Winnie.

On Monday 12 February Mandela flew to Johannesburg. On arrival he was informed that hordes of people had gathered at 8115 and that it therefore might not be safe for him to go there. Free at last, but not yet free to return to his cherished home, he and Winnie spent the night at the home of an ANC supporter in the northern suburbs of Johannesburg. On Tuesday 13 February, after addressing a packed First National Bank Stadium, Nelson Mandela walked through the gate of 8115 Vilakazi Street for the first time in more than twenty-eight years.

It had been a long road home but, fortunately for history, Alf Kumalo was there through it all to capture the memories of the famous house.

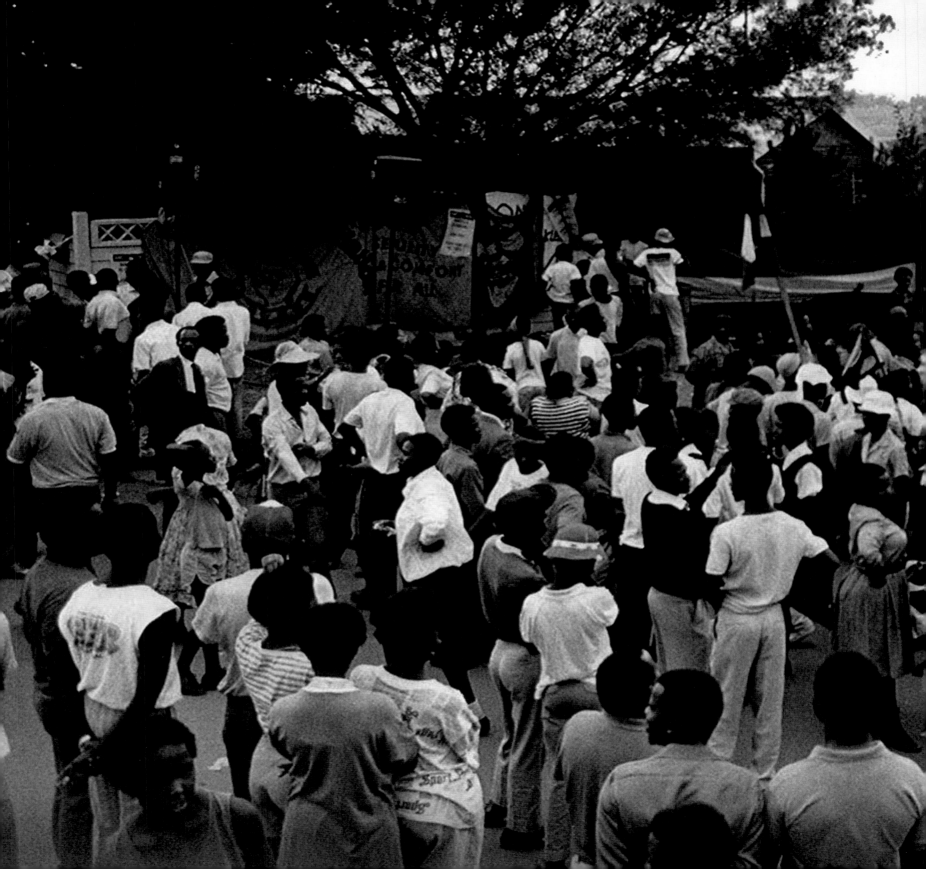

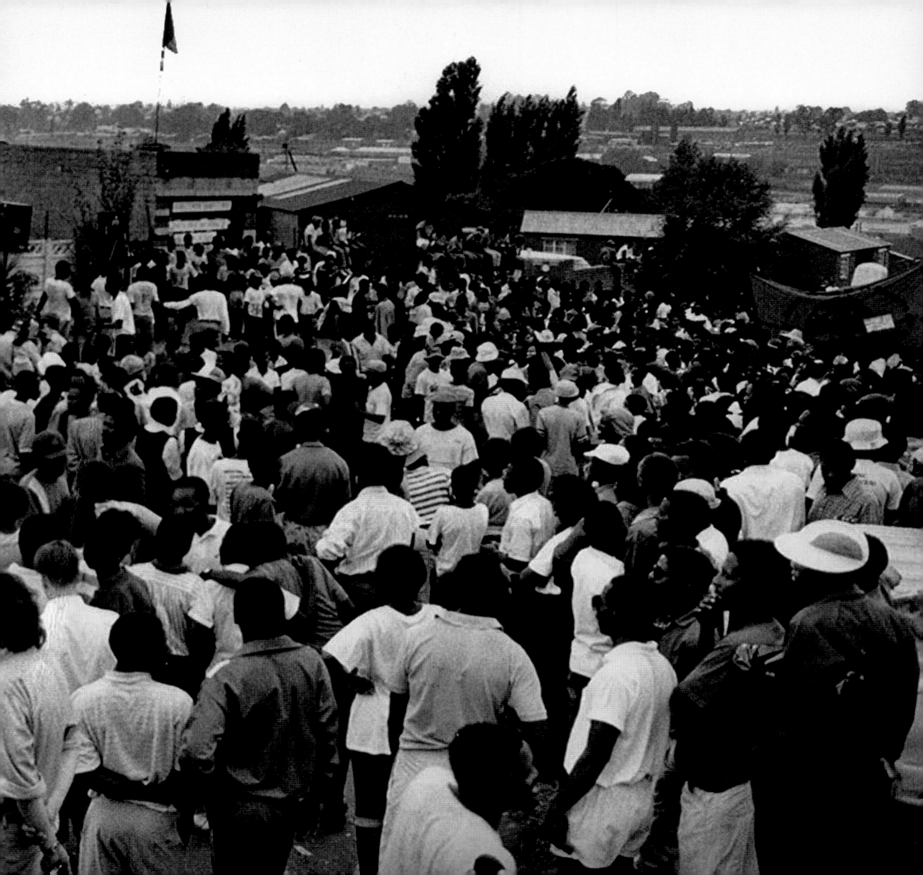

13 February 1990. Crowds gather outside 8115 on the day Nelson Mandela returned after an absence of more than twenty-seven years. (Previous pages)

General Bantu Holomisa (who would later become a member of parliament and leader of the United Democratic Movement), fellow Rivonia trialist Walter Sisulu and Nelson Mandela in conversation at 8115 a few days after Mandela's release from Victor Verster prison on 11 February 1990.

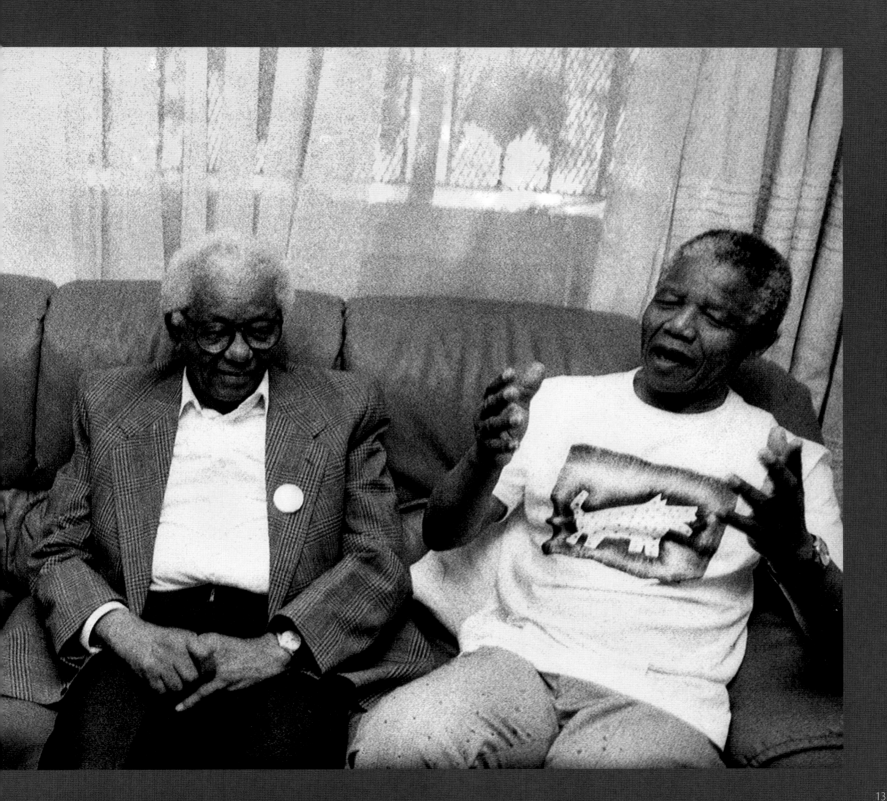

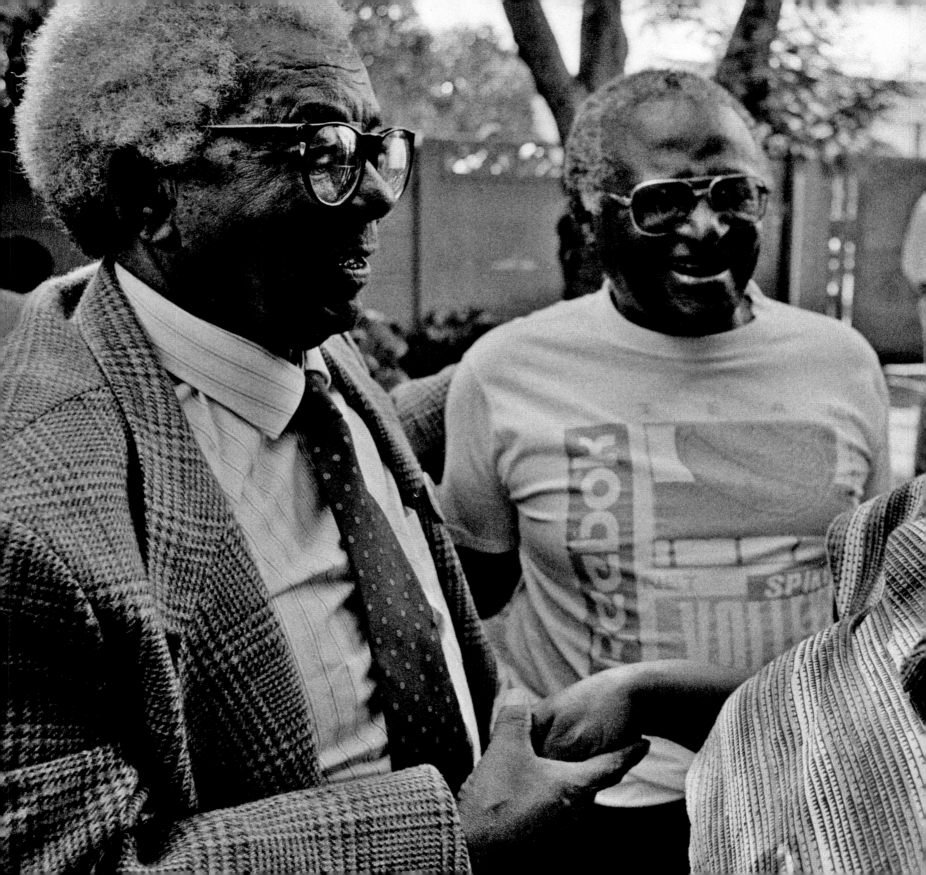

Walter Sisulu, Archbishop Emeritus Desmond
Tutu and his wife Leah share a joke at 8115
soon after Nelson Mandela's release in
February 1990.

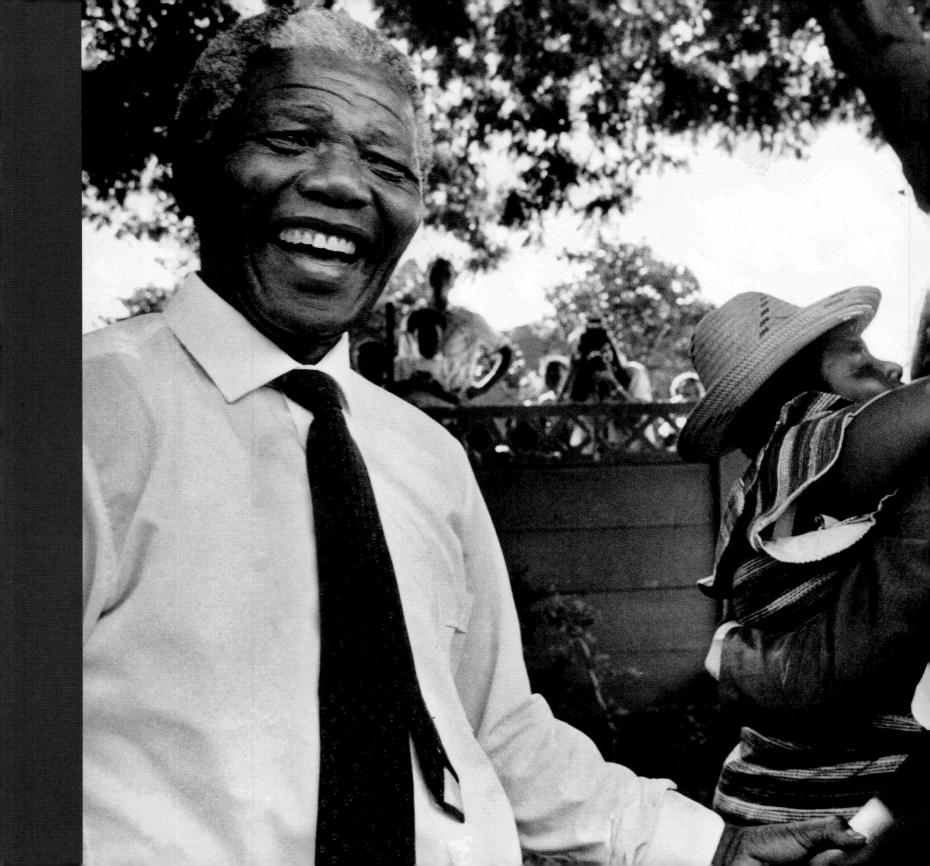

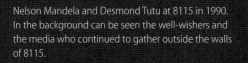

Nelson Mandela and Desmond Tutu at 8115 in 1990.
In the background can be seen the well-wishers and
the media who continued to gather outside the walls
of 8115.

Nelson and Winnie Mandela on his first
Saturday out of prison, 17 February 1990.

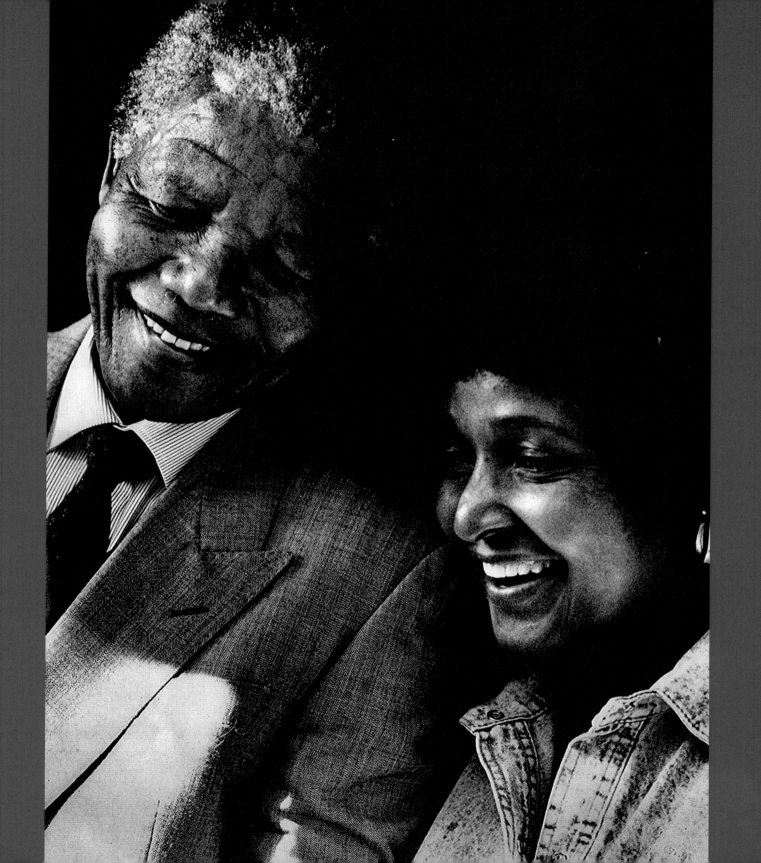

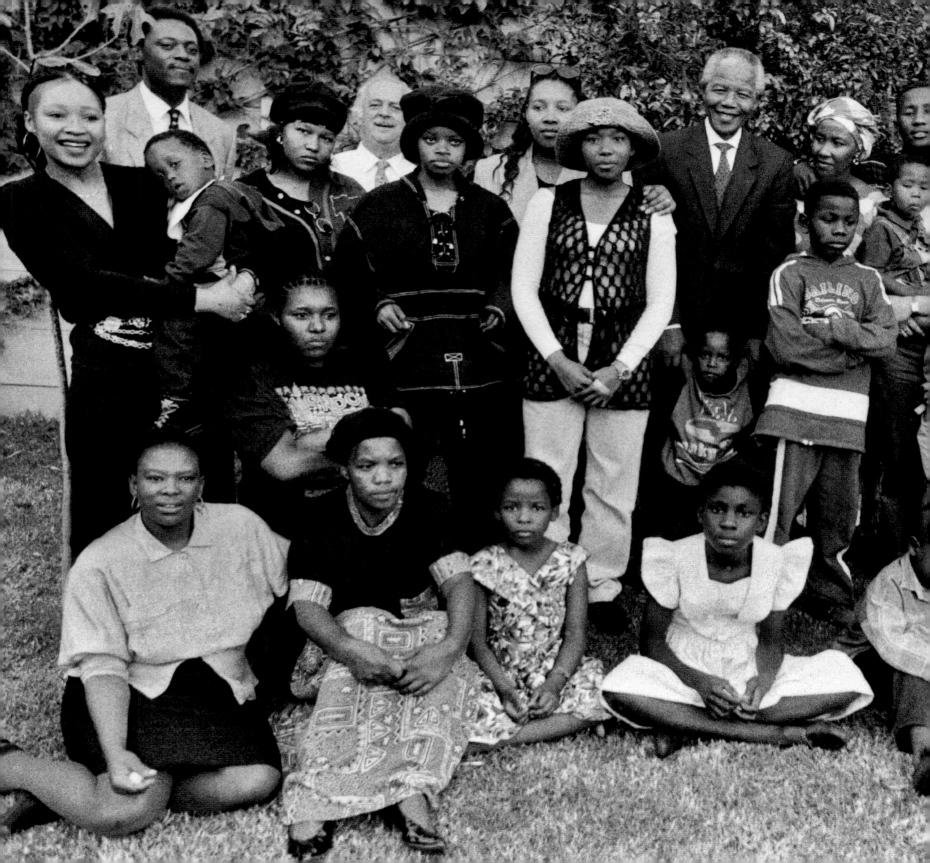

All together at last. The Mandela family with the patriarch in the garden of his new residence in Houghton after his release from prison in February 1990. While the address may have changed, all would forever remember 8115 as the true home of the Mandelas. In the back row, second from the left, is friend and veteran human rights lawyer George Bizos. Bizos was a member of the legal team for the defence in both the Treason Trial and the Rivonia Trial.

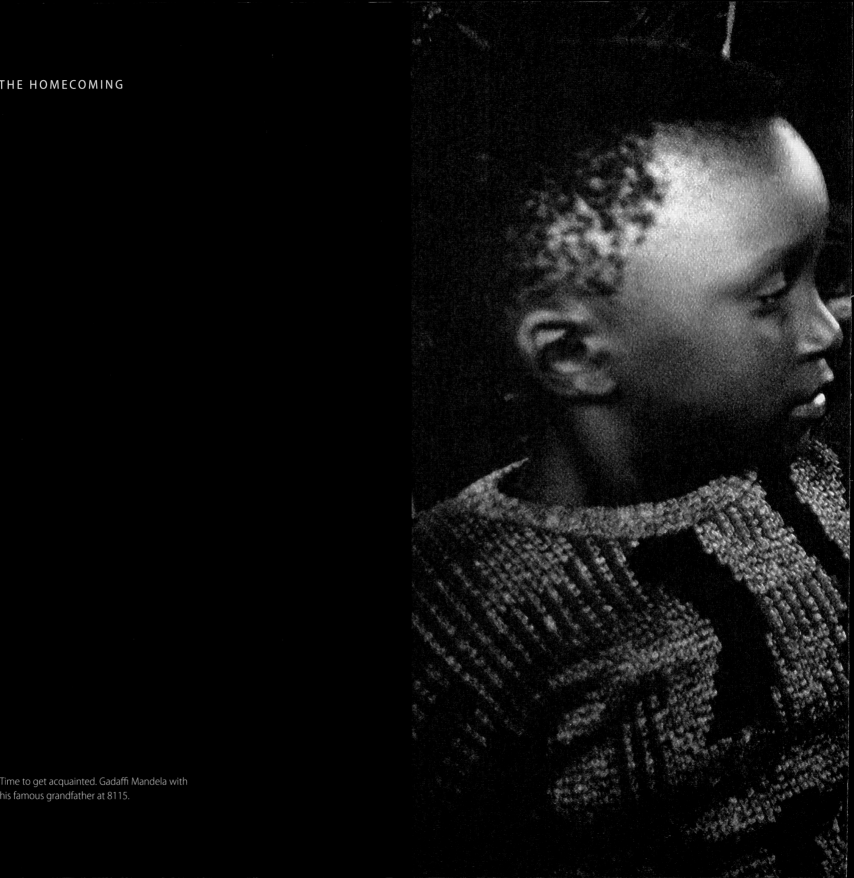

Time to get acquainted. Gadaffi Mandela with his famous grandfather at 8115.

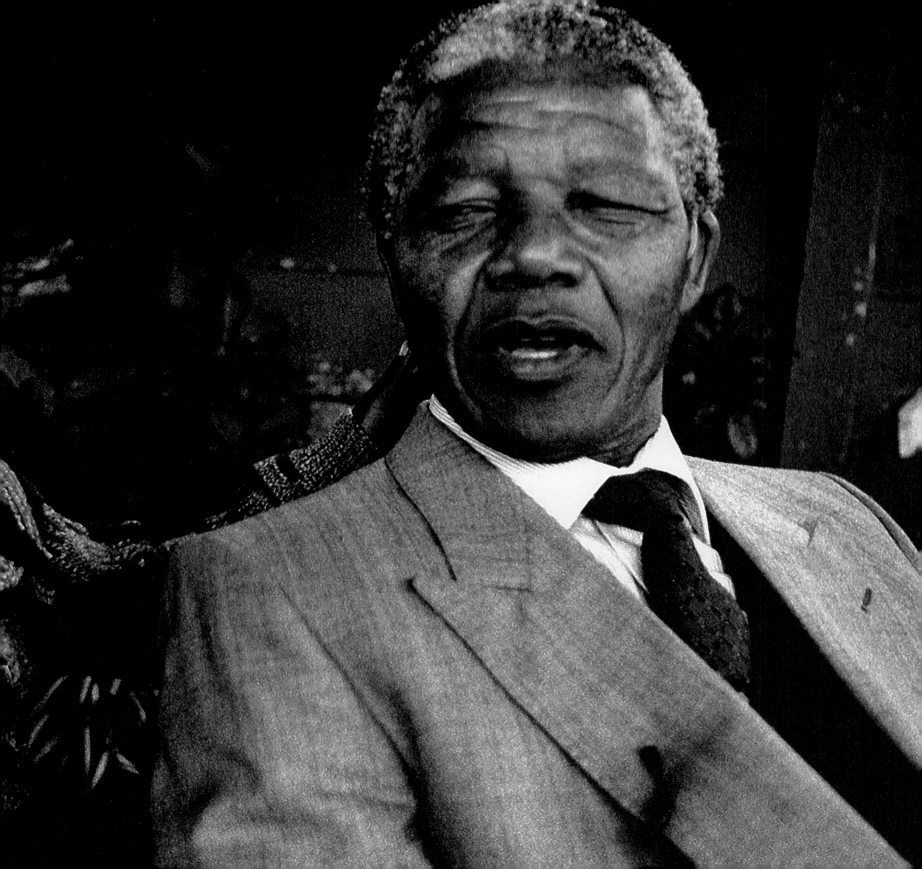

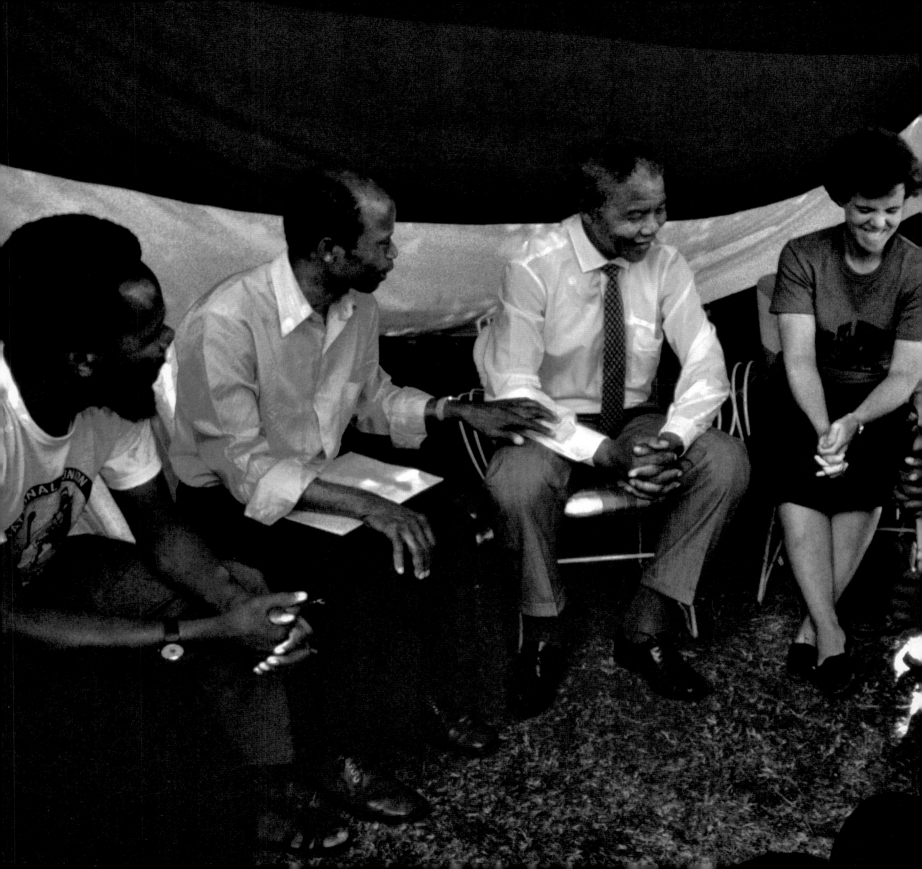

Nelson Mandela with friends (1990).

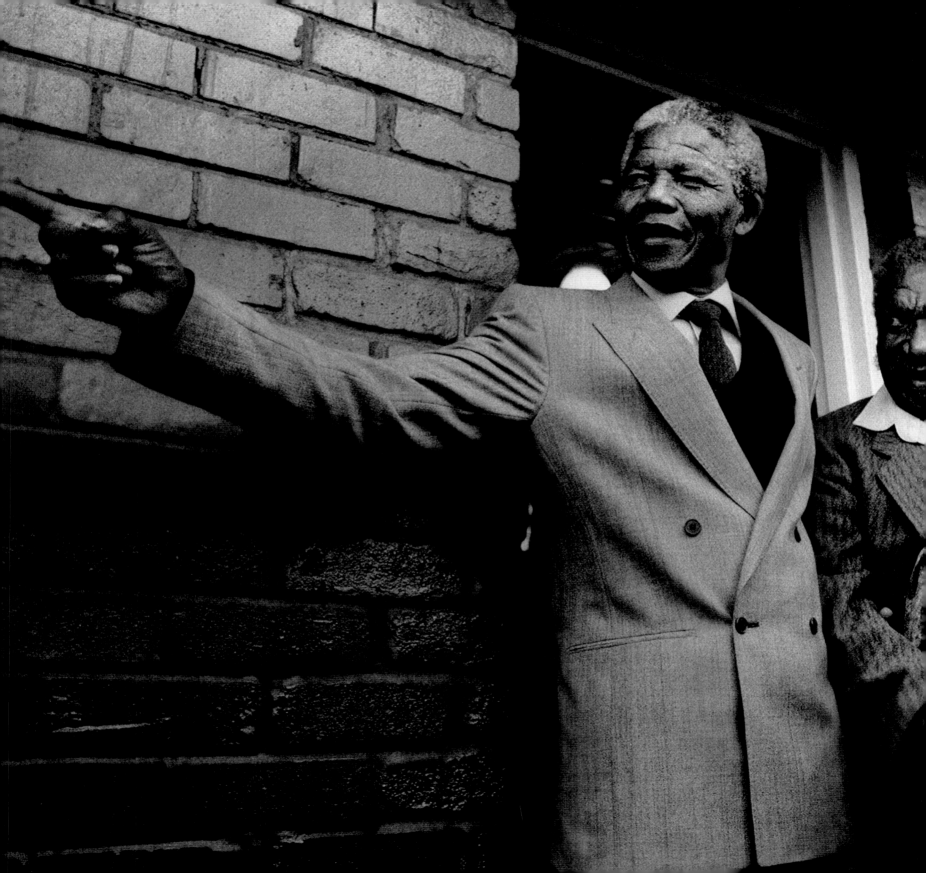

Nelson Mandela points out an old friend to former neighbour Zephania Mothopeng, his wife and Winnie. Zephania Mothopeng was a political activist first with the ANC, and then went on to help found (with Robert Sobukwe) the Pan Africanist Congress of Azania, which he would eventually lead from 1986 until his death in 1990.

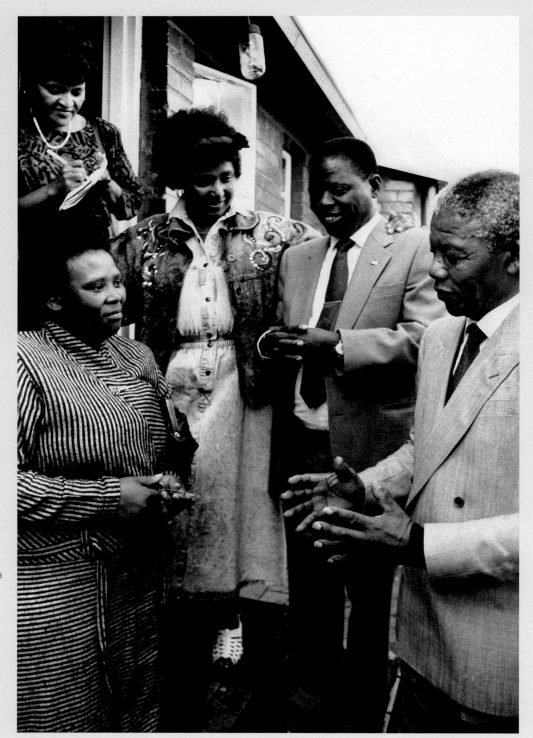

The old friend Nelson Mandela was gesturing towards in the previous image, H H Dlamlenze, a school principal, joins Nelson and Winnie Mandela and the Mothopengs at the entrance to 8115. Even though Nelson Mandela had not seen Dlamlenze in almost thirty years he immediately recognised him.

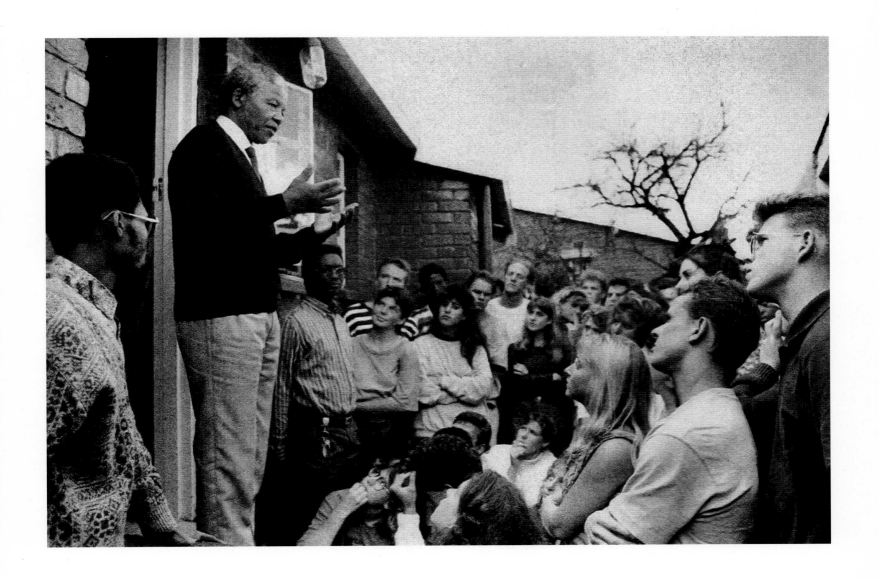

Nelson Mandela addresses University of the
Witwatersrand students outside 8115 in 1990.

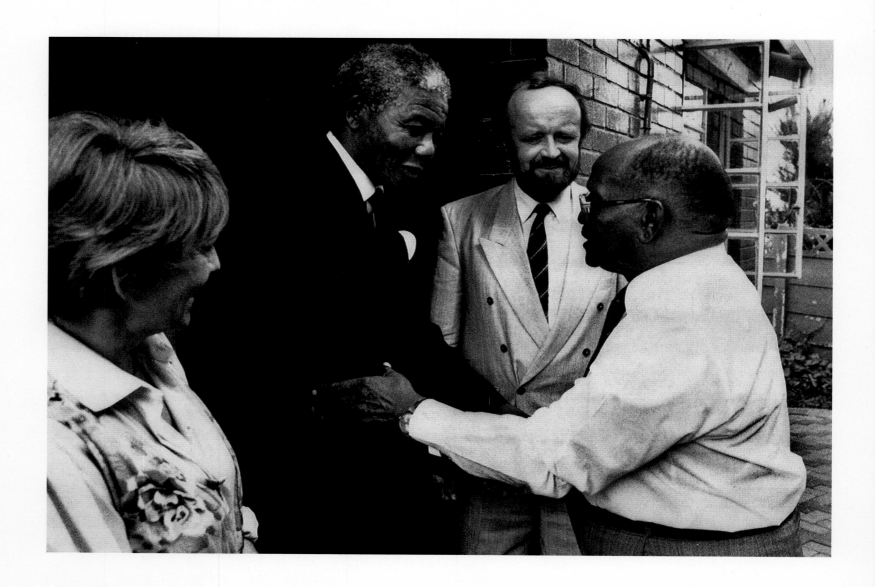

Nelson Mandela, with members of the German consulate next to him, greets multimillionaire businessman Lesolanka.

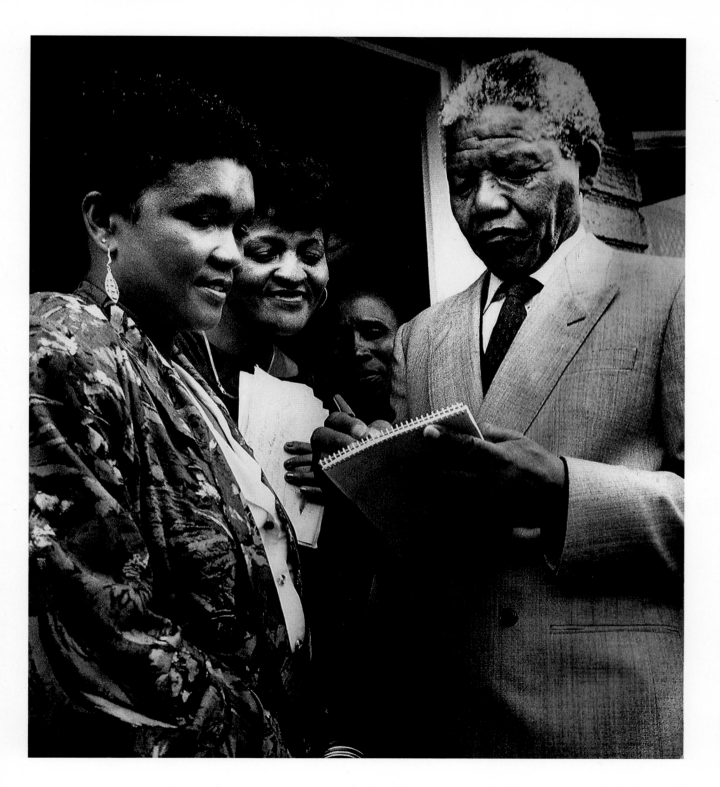

Nelson Mandela signs
an autograph for an
adoring fan, 1990s.

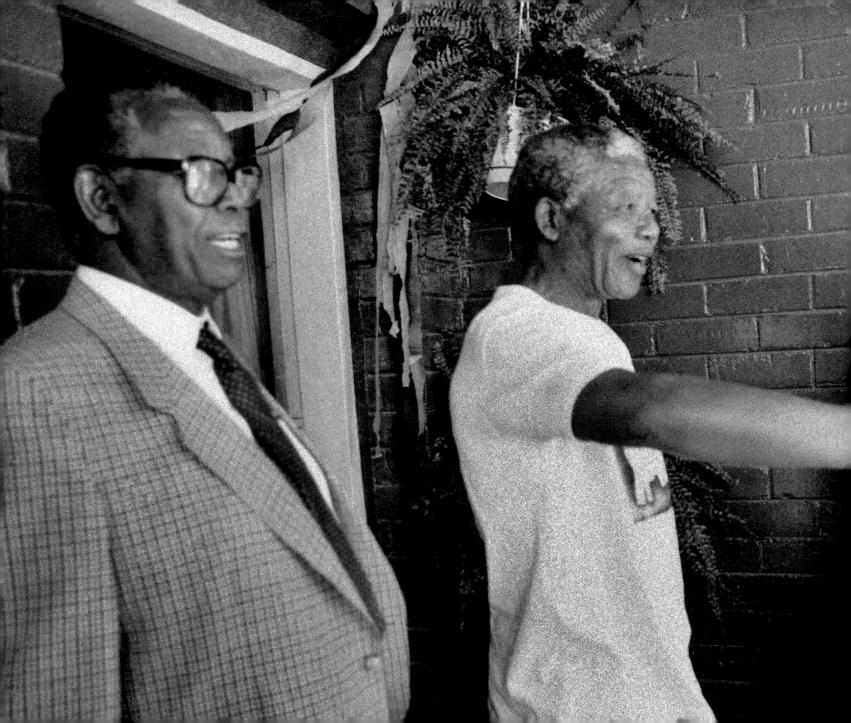

Nelson Mandela with
photographer Shadrack
Nkomo (1990).

Nelson Mandela greets young admirers from the Orlando East neighbourhood while an ANC flag flies on the line behind him.

THE HOMECOMING

Nelson Mandela makes a point
during an interview (1990).

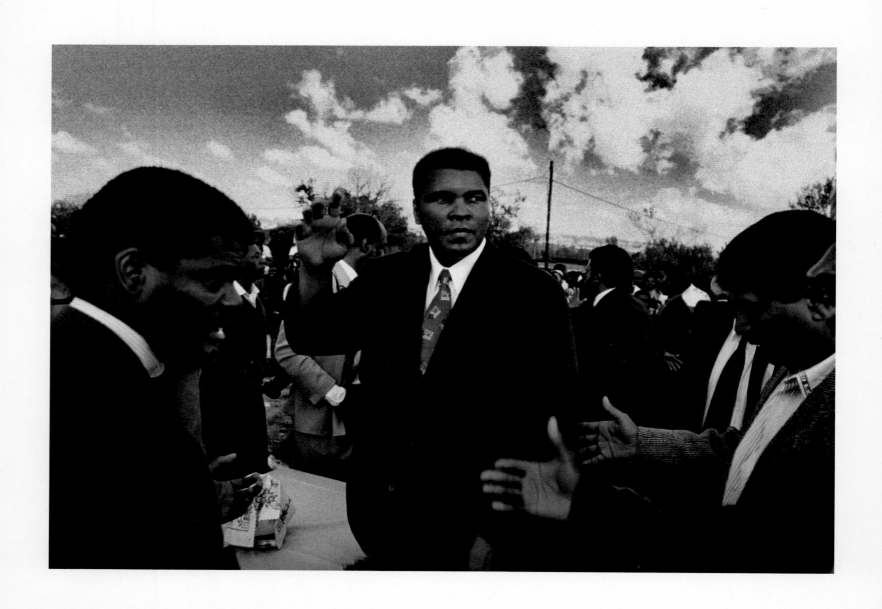

Muhammad Ali outside 8115 in 1993. Ali was
in South Africa to visit South African Muslims.

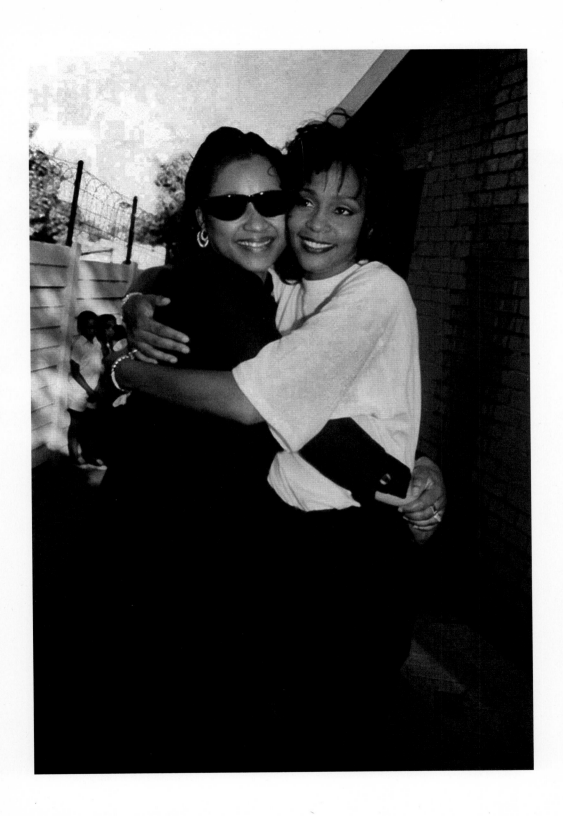

Zindzi Mandela and singer Whitney Houston in 1994. Whitney was so overcome with emotion that she cried at the entrance to 8115. When Nelson Mandela first visited the White House after becoming president, Whitney performed for him and President Bill Clinton.

THE HOMECOMING

Winnie and Nelson Mandela. This photograph
was taken during the first week after Nelson
Mandela's release from prison in 1990.